How Photographs Are Sold

Alain Briot

How Photographs Are Sold

Stories and Examples of How
Fine Art Photographers Sell Their Work

rocky**nook**

Editor: Joan Dixon
Layout: Petra Strauch
Cover Design: Helmut Kraus, www.exclam.de
Printer: Friesens Corporation
Printed in Canada

ISBN: 978-1-933952-93-2

1st Edition 2014
© 2014 Alain Briot

Rocky Nook, Inc.
802 E. Cota Street, 3rd Floor
Santa Barbara, CA 93103
www.rockynook.com

Library of Congress Cataloging-in-Publication Data

Briot, Alain.
 How photographs are sold : stories and examples of how fine art photographers sell their work /
by Alain Briot.
 pages cm
Includes bibliographical references and index.
 ISBN 978-1-933952-93-2 (softcover : alk. paper)
 1. Photographs--Marketing--Case studies. 2. Selling--Photographs--Case studies. 3. Photography,
Artistic--Case studies. I. Title.
 TR581.B749 2013
 770.68'8--dc23
 2013031157

Distributed by O'Reilly Media
1005 Gravenstein Highway North
Sebastopol, CA 95472

This book is dedicated to artists all over the world
who want to live their dream
and make a living selling their fine art photographs.

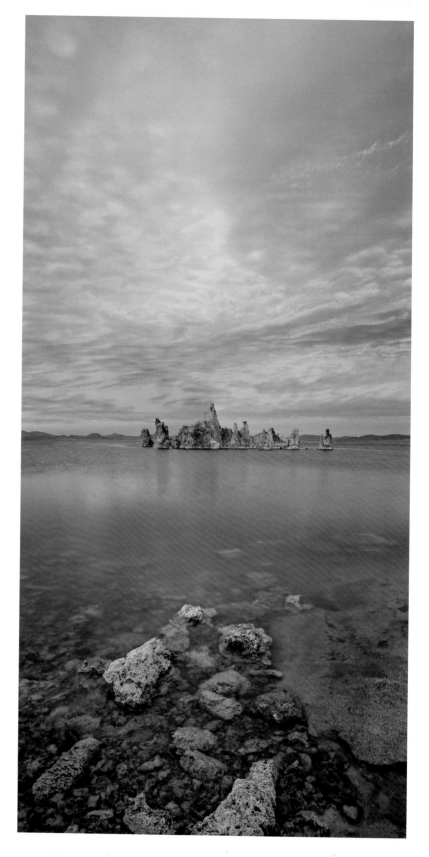

Table of Contents

Preface . xi

Getting Started . 1
Introduction . 2
Are You Ready to Sell Your Work? . 6
Are You *Really* Selling Your Work? . 8
 Your Goals Define Your Venue . 9
My Approach to Teaching and Marketing . 11
 Can You Sell My Work? . 11
 How We Learn . 12

Part 1: How Fine Art Photographs Are Sold and What Happens
 in the Process . 15
Introduction to Part 1 . 17
Story 1 Telling Stories to Sell Your Work . 18
Story 2 You Can Never Make It Too Exciting! . 21
Story 3 Nobody Is Too Young to Buy Art . 24
Story 4 Emotion Sells Fine Art . 25
Story 5 Education Sells Art . 27
Story 6 Discover Before You Sell . 28
Story 7 Bubble Wrap Makes the Sale! . 31
Story 8 Show It In a Bin . 32
Story 9 Anger – Don't Feel It . 34
Story 10 Personalize It to Sell It . 37
Story 11 Uniqueness Sells . 39
Story 12 Light Sells the Art . 44
Story 13 Competitors . 46
Story 14 Make Your Customers Feel Comfortable . 49
Story 15 Artist Statement Stories Sell . 51

◄ *Mono Lake Sunset Vertical Collage* © Alain Briot

Part 2: Eight Artists: In Their Own Words . 57
Introduction to Part 2 . 59
Story 1 Maggie Leef: Selling Wholesale to Retail Stores 60
Story 2 Bill Irwin: Home Gallery Sales . 66
Story 3 Bob Fields: Gallery Representation Sales . 76
Story 4 Christophe Cassegrain: Sales on Personal Website 84
Story 5 Carl Johnson: Fine Art Stock Image and Print Sales on Personal
 Website, and Custom Assignments . 92
Story 6 Ruth C. Taylor: Selling Retail at Fine Art Shows 98
Story 7 Carol Boltz Mellema: Fine Art Photography Portraits 104
Story 8 J.R. Lancaster: Sales in Personal Brick-and-Mortar Gallery 112

Part 3: What Artists Do and Don't Do: Problems and Solutions 123
Introduction to Part 3 . 125
Story 1 Maria: Pricing . 126
Story 2 Jane: Negotiating . 127
Story 3 Kent: Praise vs. Sales . 129
Story 4 James: Not Needing the Income . 131
Story 5 Marie: A Successful Show . 133
Story 6 John: Fish Marketing . 134
Story 7 Sylvie: A Lack of Promotion . 136
Story 8 Berndt: The Flower of the Day . 137
Story 9 Craig: From Commercial to Fine Art Photography 139
Story 10 Jay: Doing Anything to Make a Sale . 141
Story 11 Jean: Visiting Shows . 142
Story 12 Robert: Working with Galleries . 144
Story 13 Jerry: A Kickstarter Project . 147
Story 14 Mark: Using Flash on His Website . 152

End Notes . 155
Conclusion. 156
Epilogue . 165
Alain's Approach to His Photography. 167

Technical Information . 169

About Alain Briot . 179

Preface

It is not sufficient to see and to know the beauty of a work.
We must feel and be affected by it.
VOLTAIRE

This is my second book on marketing fine art photography. My first book on marketing, *Marketing Fine Art Photography*, was intended to be a manual—or even a tool kit, as some readers are calling it. To this end it features a multitude of tools and techniques designed to help you sell your work profitably.

I wanted this second book to be different. I wanted it to *show* you, rather than *tell* you, how art is sold. This is why I decided to feature stories showing how fine art photographs are sold rather than describe techniques telling you how fine art photographs are sold.

These two books are designed to complement each other. *Marketing Fine Art Photography* features techniques used to sell fine art photographs. *How Photographs Are Sold* features stories about photographers selling their work.

For this book I invited eight photographers to share how they sell their work. I also included stories showing you how 14 additional photographers sell their work. I invited these photographers and selected these stories to focus on specific problems that artists face and the solutions they implement to solve these problems.

In regard to selling venues, *Marketing Fine Art Photography* focuses essentially on selling photographs at art shows. *How Photographs Are Sold,* on the other hand, focuses on selling photographs in a variety of venues including galleries, stores, art shows, websites, and more.

Finally, I wanted to make this book useful to both amateurs and professionals. Photographers from a wide variety of backgrounds, styles, locations, and selling venues are represented throughout the book. While some of these artists earn a living from the sale of their work, others sell their work because of their passion for photography rather than to generate an income.

The outcome of these decisions is the book you hold in your hand. It is my sincere hope that this book will be useful to you and that it will help you sell your fine art photographs successfully.

◄ *Antelope Sky Dance* © Alain Briot

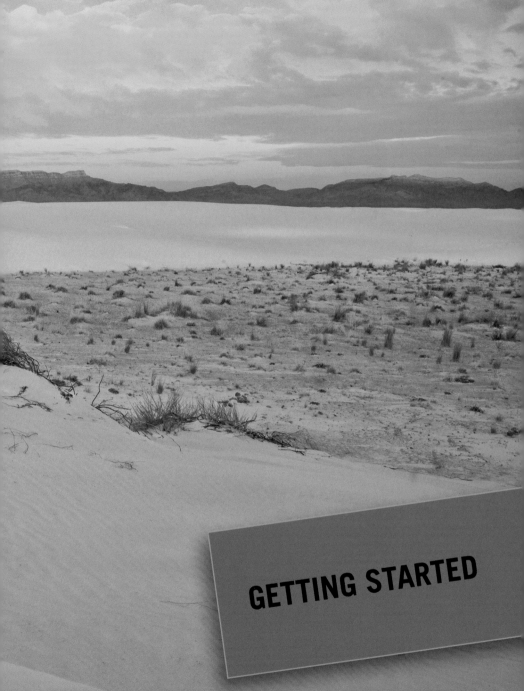

GETTING STARTED

Introduction

The most important aspect of selling your work successfully
is taking control of your own destiny instead of waiting to be discovered.
This concept changed my life.

Many things have changed since I published my first book on marketing, *Marketing Fine Art Photography*. That book was published in 2011, but I wrote it in 2007. Back then the economy was in full swing, and my marketing approach reflected that. Since then, we have had a massive recession, the real estate market tanked and home values dropped precipitously, and unemployment rose dramatically. All this, and more, contributed to a very different selling environment for fine art. Many people stopped buying fine art altogether. It makes sense. If banks are foreclosing on people's homes, there is no point in buying a fine art photograph to fit over the fireplace, bed, or couch. First, there may not be a fireplace, bed, or couch to hang it over. But more importantly, these homeowners' thoughts are elsewhere. Their goal is to save their house, not to decorate it.

We are now coming out of the recession. We may not be there yet, but there are signs that things are getting better. Home sales and construction are on the rise and home values are increasing. Although we still need to be cautiously optimistic, I believe these are good reasons to start marketing fine art photography seriously again.

However, what worked before the recession may not work today. The fine art market has changed dramatically. Buyers are no longer looking for the same things. For example, before the recession buyers were looking for excess; now they are looking for value. This is the change that affects our marketing approach the most.

Therefore, we need to adopt a new marketing approach. This does not mean revolutionizing everything we have done by changing our approach 100%. What it means is we have to adapt our marketing approach to the new economic reality. In this context the following remarks are important.

◄ *White Sands Sunrise* © Alain Briot

- People have not stopped buying fine art. Instead, they have changed *how* they buy fine art.
- Second, different people are buying fine art. This is because some people were more affected by the recession than others. For example, people with low or middle income have either stopped or significantly reduced their art purchases. This is because they were most affected by the recession and suffered the majority of foreclosures.
- People with higher incomes did not stop buying fine art, because the recession did not affect them as much. However, they are not willing to spend as much on art. While before the recession they were buying high-priced pieces, now they are buying moderately priced pieces.
- Some people have either maintained or even increased the number of fine art purchases they make. For a significant number of people, buying art has become a defense against morosity and depression. Buying art, for those who can afford it, is a positive event, a happy purchase. Buying and owning art is a ray of sunshine in an otherwise bleak and depressing socioeconomic landscape. Though many of these buyers have a high income, some have a moderate or even low income.
- A number of artists quit the fine art business during the recession. For many, quitting was the outcome of facing financial issues related to the real estate market or other financial areas hit by the recession. However, for some it was also due to emotional depression and the belief that selling art had become impossible. For these artists, the lack of a new marketing approach was the real problem.
- Many artists refused to change their sales and marketing practices during the recession. Their dependence on an outdated and now-ineffective marketing approach contributed to their demise.
- Many artists dropped their prices dramatically, even to the point where making a profit was impossible. These artists expected their sales to increase proportionally to their price decrease. However, this rarely happened because the number of art buyers had decreased tremendously during the recession. As a result, volume did not make up for loss of per-sale income and the outcome was, at best, that they went out of business before they lost everything, or at worse, that they effectively worked themselves into bankruptcy.
- Lowering prices is not a viable solution during a recession. Special offers that discount your prices are a good idea, but dropping prices permanently sends the wrong message to your clientele. It says, loud and clear, that you are desperate. While you may make a few sales to people who see a juicy opportunity, solid buyers will flee from you because they want to buy from successful

artists whose work is likely to increase in value. Since the price of your work is decreasing rather than increasing, instead of buying more, they stop buying from you altogether. A successful approach during a recession is to leave your prices unchanged, or to regularly increase your prices as you normally would. You may, however, want to increase your prices more conservatively than you would in an active economy, or slightly reduce the frequency of your price increases.

These remarks encapsulate my views on the current state of the fine art photography market.

This book will show you how to market and sell your fine art photographs. Or, to use my definition of marketing: *The purpose of this book is to show you how to attract customers and convince them to buy your work.*

The knowledge featured in this book is shared through stories about how photographs are sold and through examples of how photographers all over the world sell their work. These stories and examples, when studied and applied carefully, offer valuable insights about the direction your marketing needs to take so you can be successful at selling art in the postrecession, or early postrecession, socioeconomic landscape.

The book features three areas of focus. Part 1 is a series of stories titled *How Fine Art Photographs Are Sold and What Happens in the Process.* The purpose of this section is to show you how fine art photographs are sold through real-life experiences that my wife, Natalie, and I had while selling my work. Each story focuses on a specific aspect of the selling process.

The second area of focus is in Part 2, titled *Eight Artists: In Their Own Words,* which is a detailed presentation about how eight photographers market and sell their work. Each presentation starts with a short introduction that I wrote, followed by the artist's own description of his or her approach to the marketing and sale of their work. Photographs of the artist's selling environment are included, along with examples of their marketing materials.

The third area of focus is a series of stories in Part 3, titled *How Artists Do What They Do.* The purpose of this section is to show you how various artists approach the marketing and selling of their work. Each story presents a problem and a solution to the problem. The names of the artists have been changed, but each story is based on the actual experiences of artists whom Natalie and I know personally.

My goal in writing this book is to help you turn marketing into one of your business assets. As you will see, this second book on marketing not only goes beyond what I taught in my first marketing book, it also introduces a diversity

of new techniques that, if you implement them carefully, will help you market and sell your fine art photographs successfully in today's marketplace. Let's get started and learn how to market fine art photographs effectively and profitably!

Alain Briot
Vistancia, Arizona
February 2014

Are You Ready to Sell Your Work?

A business has to be involving, it has to be fun,
and it has to exercise your creative instincts.
RICHARD BRANSON

You have created some great photographs and you are considering selling them. Doing so makes sense. You have the skills and you want to recoup the investment you made in your photographic gear. Maybe you want to make your hobby pay for itself. Maybe you want to generate extra cash. Maybe you want to start a photography business. Or maybe you are already selling your work and you want to reach the next step with your business.

Whatever the case might be, selling your work involves marketing it. The problem is that marketing is a challenge for most photographers because marketing has very little to do with creating fine art photographs. Most artists abhor marketing their work. In fact, most artists have never studied business or marketing. I know. I was one of those artists. When I started selling my work I believed that marketing meant putting a price tag on my work. No, strike that, because at first I did not even use price tags! Just deciding what price to charge for my work seemed like marketing to me.

My early attempts at selling my work were disappointing, to say the least. It was the lack of sales that forced me to change my approach. I realized I had to study marketing, or die trying, in order to earn a living as an artist. I did study marketing, and to make a long story short, I became financially successful selling my work, making a six-figure income only two years after making the decision to embrace marketing.

In marketing, preparation is everything. This preparation encompasses many aspects. To name a few, there is the selection and creation of the pieces you will be selling; there is the preparation of your booth and display if you sell at art shows; there is the preparation of your paperwork, such as business and tax licenses, show applications, and much more.

However, there is another aspect of preparation—one that is often overlooked: the preparation of your marketing approach and materials. It is overlooked because marketing is not the forte of most photographers who are selling their work. Marketing is challenging for them; it is somewhat mysterious and

is often considered akin to twisting the customer's arm behind their back to convince them to make a purchase.

I believed this same thing, but I changed my mind and this change made me successful. I finally understood that marketing is not coercion. Instead, marketing is one of the fundamental aspects of business; one that is as important as creating artwork, preparing your show display, and getting your paperwork in order. Marketing is one of the foundations of your business. Effective marketing is one of your business assets. Ineffective marketing—or worse, lack of marketing—is one of your business liabilities. As I like to say, if you don't market, one thing will happen: nothing.

Are You *Really* Selling Your Work?

If you don't get noticed, you don't have anything.
You just have to be noticed, but the art is to be noticed naturally,
without screaming or without tricks.
LEO BURNETT

As I researched the materials featured in this book, I was shocked at the number of photographers who believe all that is required to sell their work is saying that it is for sale. There is a huge number of photographers out there who either do no marketing whatsoever or who limit themselves to telling people to come see their work either on a website, at a show, in a gallery, and so forth.

Many photographers use minimal messages such as the following:
Click on images for a larger view

Or:
Contact me

Or again:
Please send all information requests to me@myemail.com

On their websites or at art shows, many photographers use statements such as the following:
Let me know if you are interested in getting any of my photographs as greeting cards or to hang on your wall. I am also available for teaching sessions and for presentations. Just contact me by clicking on the contact button at the bottom of this page and we will arrange something.

Or:
All my photographs are available for sale on high-quality photo paper in any size. Please contact me without any obligation for more detailed information and prices.

Examples like these, in a multitude of variations, abound. I could go on, but these are enough to make my point: this is not marketing. This is wishful thinking. This may seem critical, but it needs to be said. If you have been using these techniques and have sold something this way, you have been fortunate. You are lucky, or you have customers who love you, or both. However, if you want to go beyond these few occasional sales, you will have to do some real marketing.

At this point you may ask, what is *real* marketing? I will state it as clearly as I possibly can: *Marketing is attracting customers and convincing them to buy your work.*

If you do nothing to attract customers besides asking them to visit your website, gallery, show, store, and so forth, and if you do nothing to convince them to buy your work besides telling them that it is "for sale" or to "contact you," you are not marketing. What you are doing is providing people with an opportunity to enjoy looking at your work.

Until you do *real* marketing you will only make a few occasional sales, at best. If you are satisfied with this situation and you do not seek to make an income from your work, I have no objections. But if you find this situation frustrating and you do want to make an income from your work, you need to study marketing and then implement what you learn.

If you find yourself in this situation, don't feel badly about it. I was in this situation myself. My early selling attempts were completely devoid of marketing. In fact, my first website was a showcase site on which I displayed my photographs but made no attempt to sell them in any way, shape, or form. I had great expectations for this first website, so the fact that I sold nothing through it was a disappointment. However, today it is no longer surprising. I now understand that in order to sell my work, I need to market it, and that was something I was not doing. What I needed to do, and what I have done since, was study how to market my photographs in order to attract customers and convince them to buy my work.

Your Goals Define Your Venue

Many photographers want their photographs to sell because of their artistic quality, not because of the quality of their marketing. These photographers want their work to sell itself, and they see marketing as treachery and manipulation. If you are one of these photographers, know that I see nothing wrong with your goal; I only see something wrong with your venue. You need to enter your work in art competitions and make your goal to receive artistic awards. You should not start a business and hope to sell your work to people who love it without doing anything more than telling them to call you or any of the other ineffective marketing approaches I mentioned earlier.

On the other hand, if you find that some of the statements in this introduction hit close to home, and if you see yourself in some of the examples of ineffective maketing I present here, know that this is a good thing. After all, you purchased this book to help you market your work more effectively, and the goal of this book

is to show you how to do that. Keep reading, then put what you learn into action by using it on your website, during your shows, in your gallery, and in any other selling venue you might use. If you do, you will be surprised at how much better your artwork will sell.

My Approach to Teaching and Marketing

What would you attempt to do if you knew you could not fail?
UNKNOWN

Can You Sell My Work?

I regularly receive emails from photographers asking me if I can sell their photographs. Typically these emails read like this: "I have a fantastic photograph of (insert location or subject here). I know it's worth a fortune (millions, sometimes). I just need help selling it." Some people offer to take me in as a partner for a share of the profits (no thanks), others just want to find the magic person who is going to make them rich (there's no such person).

Sorry, folks, but none of this will work. You don't make money in photography because you believe, rightly or wrongly, that you have a million-dollar photograph. You make money in photography because you have learned how to market and sell your work yourself. Furthermore, million-dollar photographs are rare, and when an image actually generates that type of income, it is due to superb marketing and not to the photograph being unique or good.

It is important to keep this in mind: *A bad photograph that is well marketed will outsell a good photograph that is poorly marketed.*

It doesn't matter if you have a million-dollar photograph; it is meaningless if you don't know how to market it. Someone else, with a $100 photograph and with effective marketing put into place will outsell you. The goal is to have a great photo *and* to practice fantastic marketing. To get started, what you need first is marketing knowledge.

Many photographers who want to start selling their work try to find someone who is willing to sell their photos for them and who will make them wealthy. I know everything about that because I was one of those photographers. I looked everywhere for such a person but did not find one. It was during this fruitless search that I realized I had to learn how to sell my work myself. I succeeded because I learned how to control my destiny. Instead of asking others to make me rich, I went out and made myself rich. Fourteen years ago I had nothing. Now I have more than I ever dreamed of. The photograph on the cover of my first book

on marketing paid for my first house. I made every sale by myself after learning how to market and sell my work.

I studied at the school of hard knocks. I didn't take marketing classes, and I didn't study for an MBA. My experience is practical, not theoretical. It comes from the trenches, not from books. Learning that way wasn't fun. I decided to write about and teach marketing to offer you a better way to gain this knowledge. By sharing my knowledge with you, I can teach you how to do what I do. It starts by making the decision to control your own destiny instead of looking for someone (or something, such as luck or the lottery) to make it happen for you.

My no-nonsense approach to teaching marketing is based on my personal experience, not on books or college classes. I teach you how to do what I do. I have no secrets because I believe there are opportunities for all of us out there.

If your goal is to sell your photographs, you will have to learn marketing, either from me or from someone else. There's no way around it. There's no silver bullet, and you won't get rich overnight. Things moved fast for me, but it still took me four years of constant work to become successful. The claim of getting rich overnight is greatly exaggerated. In fact, it simply does not happen that way. Success comes from hard work and long hours, not from luck, happenstance, or some other twist of fate. Anyone who tells you otherwise is either lying or delusional. If it were that easy, if there was a silver bullet and if we could become millionaires overnight, we would all be doing it! Everyone would be rolling in the dough, living in big houses, retiring at 40, and driving Bentleys! Things are far from being that way because being successful is uncommon. Success is also a lot of work. Only those who learn the lessons and who are willing to work as hard as it takes, succeed. I had to do it that way. Everyone who is successful in this business has to do it that way.

How We Learn

In the context of this discussion on teaching it is useful to list the characteristics that are typical of a good student.

Good students:
- Are not afraid to ask questions
- Know that there are no stupid questions
- Are excited about what they are learning
- Are sponges sucking up knowledge rather than containers waiting to be filled with a funnel
- Are involved in the learning process

- ❯ Are not waiting to be taught
- ❯ Are teachable and open to new knowledge
- ❯ Do not argue with the teacher on subjects they are not expert in
- ❯ Reflect on what has been learned
- ❯ Look for ways to immediately apply what was learned
- ❯ Don't reject new knowledge a priori without testing if it works or not
- ❯ Are not afraid to apply what they have learned
- ❯ Want to teach others

Let's focus on making these characteristics ours so that we become lifelong students of marketing and salesmanship!

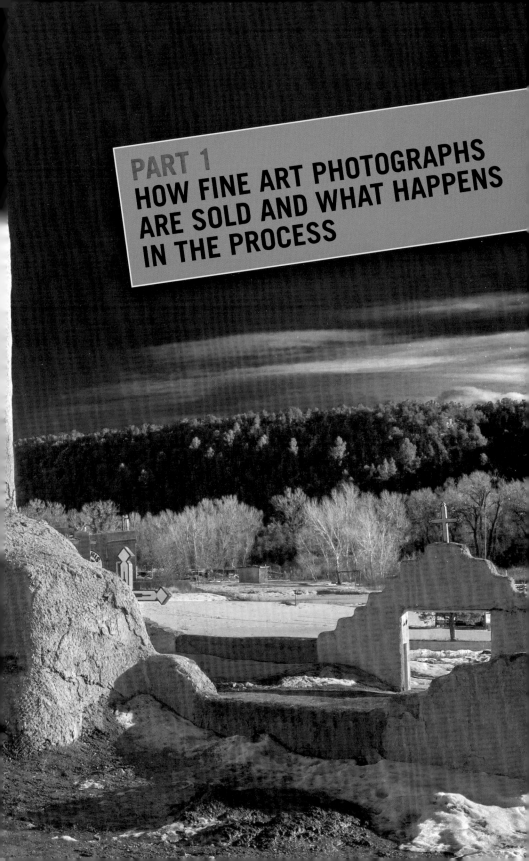

HOW FINE ART PHOTOGRAPHS ARE SOLD AND WHAT HAPPENS IN THE PROCESS

Introduction to Part 1

The more informative your advertising, the more persuasive it will be.
DAVID OGILVY

This section features real-life experiences that my wife Natalie and I had while selling my fine art photographs. Each story exemplifies a specific aspect of the buying and selling process.

The goal of these stories is to show you how fine art photographs are sold and what happens when they do sell. The goal is also to demonstrate some of the most important aspects of marketing and salesmanship. To this end, each story focuses on a specific aspect of the selling process.

◂ *Alabama Hills Arch at Sunset #1* © Alain Briot

Story 1

Telling Stories to Sell Your Work

After nourishment, shelter and companionship,
stories are the thing we need most in the world.
PHILIP PULLMAN

Telling stories about your work carries a lot of weight in the eyes of your customers and collectors. The story of how you created a particular piece can be anything from the final push a customer needs to make a purchase to an enlightening moment that reveals something about the piece that can be life-changing to a customer. Stories sell the art by making the photograph come alive and by giving the customer a narrative he or she can share with family and friends.

A couple once asked me if I remembered the exact date when I took a specific photograph. It was a photograph of the Grand Canyon at sunrise created from Hopi Point, one of the overlooks on the West Rim Drive of the Grand Canyon. I did not know why they wanted this information, but I proceeded to give them the information they asked for. Fortunately, Natalie was with me and she remembered the exact month, day, and year when I captured the specific photograph they were interested in.

Seeing that they were fascinated with the image, I did not stop there. I continued by explaining how I woke up early that morning and hiked to the overlook in the dark, carrying my camera gear and hoping that the sunrise would reward my efforts. The hike is uphill and even though the rim road goes right next to the overlook, the road is closed to private cars; back when I created the image there was no shuttle bus until 9 a.m., much too late to capture sunrise. I explained how I set up in the dark and how I used a panoramic camera, a Fuji 6×17 with a 90mm lens in this instance, because I wanted to capture the entire panoramic view from east to west.

I explained how the print was created to express how I felt that morning, and that the colors on the horizon show the transition from day to night—day on the right side, which faces east, and night on the left side of the image, which faces west. I explained how the clouds on that particular morning formed a V shape right in the center of the image, offering an ideal composition for a panorama, and how the colors in the clouds complement the colors in the landscape itself,

the colors of the canyon buttes and formations, and the color of the Colorado River, forming a coherent and aesthetically pleasing color palette.

They listened intensely, staying quiet the whole time, taking it in. After I was done talking they asked to be excused so they could talk to each other. When they returned they simply said, "Can we take this one with us?" I was surprised at the question because this was my largest piece, over 7 feet wide plus framing, and most people had it shipped because of the difficulty of taking it with them while travelling. I was also surprised because this was a four thousand-dollar piece and usually people either negotiated the price, or at least discussed it before making a decision. Not this time. I did not even have to close the sale; they did this on their own, having already decided they were going to purchase it.

I said sure, and then asked, "Do you have a vehicle large enough to carry it?" They said that they drove a full-size pickup truck and that it would fit inside. They then looked at each other and he said, "I proposed to her at this overlook on that day. Not at sunrise, but later in the day. We've been looking for a photograph that was taken from this overlook ever since, and you are the only one who has one, plus it is beautiful and it was taken the day I proposed. There's no way we can pass on it." As he said this he gave me his credit card. I mentioned the price, plus tax since it wasn't shipped out of state, but I don't think that it mattered at all. Clearly, the decision was not made on the basis of price.

I am sharing this with you to show how important telling a story, as accurately as possible, is when selling fine art photographs, or any other type of fine art for that matter. Had I not told that story, or had I simply said, "It was taken at Hopi Point at sunrise," I would not have made the sale. The story not only mattered to them, it was the reason they purchased the piece. I am sure they continue to en-joy it to this day. In fact, I received a letter from them a few months later in which they told me how much the piece meant to them and they enclosed a photograph of the artwork displayed prominently in their home over the fireplace.

A story such as the one I just mentioned is really a narrative about your work. I write narratives about most of my pieces. Often, it is these narratives that make the sale because they provide the little extra push that collectors need to make a purchasing decision.

I encourage you to tell stories about what inspired you to create a specific photograph. While a collector might be originally attracted to your work for aesthetic reasons, a story can go a long way toward transforming their initial attraction to an emotional response that leads to a buying decision. Knowing behind-the-scenes details about a piece that only the artist can share goes a long way toward generating a feeling of ownership and of a privileged relationship with a specific piece. While viewers are initially involved with the work on a

visual level, after hearing the artist's story they are engaged on a emotional and intellectual level. This raises their level of involvement from simple curiosity to serious consideration and, if you do a good job, to a desire to own the piece that has by then become part of their experience.

Be enthusiastic when telling the story of a specific photograph. Enthusiasm is contagious, so if you are enthusiastic about your work, your listeners—your clients—will in turn become enthusiastic about it. Enthusiasm ends with -*iasm*, which stands for I Am Sold Myself. You must be proud of your work in order to sell it and nothing achieves this goal better than being enthusiastic about your photography!

Story 2

You Can Never Make It Too Exciting!

Luck is the residue of design.
BRANCH RICKEY

Y ou can never make a work of art too exciting. While you may think it is over the top, the final say rests with the customers. Eventually, they decide whether something is to their liking or not.

For years Natalie and I sold what we called *three-picture panoramas with decorated mats*. These were pieces that consisted of three photographs, usually on a specific theme such as natural arches, sunsets, sunrises, natural phenomena, and so on. We matted these in a double mat with three openings for the photographs in the center and two small openings for decorative items on each side of the center photograph. In the small openings we placed decorative Native American items such as bits of turquoise, wild turkey feathers, silver castings of horses, carved bone feathers, and so on. Instead of having square corners, each of the six mat openings had intricately cut Southwest design corners called *palomino*. The top mat was beige while the bottom mat was dark brown. These contrasting colors made the palomino design really stand out. We added spacers between the top and the bottom mat to provide sufficient depth for the decor items. This made the finished piece nearly half an inch deep, giving it a substantial feel and look. The complexity of this piece, its unique look, and its sophisticated craftsmanship made it extremely popular with customers.

We also carried Italian inlaid frames that were very popular. These frames were made from maple burl wood and had a design strip inlaid around the face of the frame. They were a deep, dark reddish-brown and were finished with a glossy lacquer. These frames were just as popular as the three-picture panoramas with decorated mats.

However, we used plain burl frames for the three-picture panoramas because the inlaid frames were not deep enough to accommodate a half-inch deep mat. These plain burl frames were also dark brown and had a glossy lacquer finish, but they did not have an inlay design. We also were concerned that combining an inlaid frame with a decorated mat would create a piece that would be a tad too exciting as well as overly expensive.

For years we had requests from customers to combine the two, and each time we had such a request we told them that the frames were not deep enough to accommodate a half-inch thick mat, that placing the two together would be over the top, and that we would have to charge a high price because the frame and the decorated mats were both expensive items. People listened to us and bought the piece the way we framed it, with the plain burl frame.

One day a customer asked us to combine the two and we gave her the usual answer. But that time our answer did not fly. The customer looked straight at us, took on a very serious manner, and said, "Either you put this decorated mat in this inlaid frame, or I don't buy anything." It was a slow day, with only a few customers, and we needed to make sales, so we said yes. We did mention a second time that most likely the mat wouldn't fit in the frame, and that the price would be quite a bit higher, but the customer was unfazed by our arguments. So we proceeded to do what had been asked of us many times before but had never actually been tried.

To our surprise the mat did fit in the frame. It bulged a little on the back, but the customer did not care. In fact, she was delighted by the result. She paid for it, gave all the signs of a very satisfied customer, and left with her purchase under her arm.

This success story convinced us to begin offering this combination. So, from that day forward we offered three-picture panoramas in decorated mats framed in inlaid burl wood frames. We priced them at a premium and they sold like crazy; so much so that we could not hold on to them. No matter how many we made, we never had enough. We kept increasing the price, but we never were able to get to where that would discourage customers. It became one of our best-selling items—one we could not imagine being without in order to have a successful show.

Listen to your customers and don't overthink their requests. If they want something you are not offering, and if satisfying their request is possible, just do it. The customer is king and if they are willing to pay what you feel is fair to satisfy their request, you can only win by accommodating them.

◄ *Surrealist Cloudscape Hoodoo* © Alain Briot

Story 3

Nobody Is Too Young to Buy Art

Honesty is the single most important factor having a direct bearing on the final success of an individual, corporation, or product.
ED MCMAHON

Prequalifying potential customers based on their looks is a huge mistake. Natalie and I were on the back porch of the El Tovar Hotel at Grand Canyon National Park, where we and other artists had our work on display. A young girl stopped by to look at my photographs of the Grand Canyon.

We said hi to the girl, who looked about 12 years of age. "I just love your photographs," she said to us as she was carefully looking through one of the bins of matted photographs.

"Thank you. Where are your parents?" we asked. "Oh, they are upstairs unpacking and they let me come down to look at the artwork," the girl said. We talked with her for a while, showed her images of sunrise and sunset from the overlook at the hotel, and then she left.

Later that day she came back with her parents. Her father walked over to the other side of the porch where another photographer was selling his work and chatted with him for quite a while.

The young girl stayed on our side of the porch, waiting for her father. Tired of waiting, she eventually went over to the other side and brought her father over to where we were. "This is the artist I was telling you about," she told her dad. She then began to show him her favorite images of the Grand Canyon, explaining to him what we had told her previously about where the photographs were taken from.

Her father smiled at us and said, "Hi, nice to meet you. My daughter really wanted me to come down and see your work. I want to buy several of them." He then showed us which ones he wanted. When his selection was complete he had purchased five framed photographs. As he was paying us he said, "The reason I am buying from you is because you were so nice to my daughter and because she really likes your work."

Just because they are children does not mean that they are not customers. Don't disregard anyone's interest in your work. Being nice and friendly costs you nothing and may generate unexpected sales.

Story 4

Emotion Sells Fine Art

The big secret in life is that there is no big secret.
Whatever your goal, you can get there if you're willing to work.
OPRAH WINFREY

Focusing your marketing on the emotional impact of your photographs will help you sell more because people buy photographs for emotional reasons, not for logical reasons.

When we started selling my photographs I talked endlessly to customers about the camera I used to take the photographs, the printer I used to make the prints, which ink and paper combination I liked best, which size was the ideal size for a given photograph, and I mentioned countless other technical details to them.

I loved talking about the technical aspects of my work, and at first I thought that my customers enjoyed learning about these aspects as well. However, I noticed that most of the time this did not lead to a sale. Customers would listen to me, nod their head, say something such as, "Very interesting, thank you," and then excuse themselves and leave my booth.

I wondered why this happened, so I paid close attention to their expressions while I explained the technical aspects of my photography. At first, when I started talking to them, they were excited to hear what I had to say. But after a while they showed signs they were losing interest. While my customers were interested in what I had to say, it became clear that my techno-talk was over their heads. While they acted as if they were following me, in reality their attention was drifting away and they would leave as soon as I would stop talking.

So I tried something else. Instead of telling them about the technical aspects of my work, I started telling them about the aesthetic aspects of my photographs. I told them about what attracted me to a specific location and why I decided to compose a piece the way I did. I told them about how long I waited for the light to make the landscape look beautiful. I told them about the colors I used, why I selected a specific frame, and shared with them many other details related to my aesthetic decisions. Often, as I spoke to them, the conversation became an exchange between them and me. They asked questions about why I did this or that. They agreed with my choices and made the point that the photograph

wouldn't look as good if it had been taken at a different time, or if I had used a different composition or used a different frame. This was no longer a one-sided talk. It was an exciting conversation during which we exchanged emotional responses about my work.

At the end of this exchange, instead of walking away, most customers would make a purchase, often a significant one. They usually purchased the photograph we had been talking about together. Sometimes they purchased several photographs, and for each one a similar exchange took place. What had been a one-sided conversation was now a passionate exchange, one that resulted in multiple sales.

Through this experience I learned that people purchase photographs for emotional reasons, not for logical reasons. Knowing the camera, the printer, the ink, the paper, and the other gear and techniques I used did not make them want to own my work. What made them want to bring one of my photographs home with them was knowing why this photograph was meaningful to me, why I was attracted to create it, what made me choose a specific place, time, and light, why I matted and framed it a certain way, and why I made other emotionally-motivated decisions. In short, it was my artistic vision they wanted me to talk about, because it is this vision that creates an emotional connection to the photograph.

People purchase photographs for emotional reasons. Presenting technical prowess to your buying audience does not increase sales. Explaining your artistic vision, your passion, and the reasons you created a specific piece is what generates sales. Being able to relate emotionally to a work of art is the main reason people invest in art.

Story 5

Education Sells Art

The man who stops advertising to save money
is like the man who stops the clock to save time.
ANONYMOUS

Don't be just a salesperson. People enjoy learning new things. Educating them about you, your artwork, and the places that you photograph will make them see you as someone who is helpful and not just there to sell something.

After we started selling artwork at Grand Canyon National Park we bought several panoramic postcards of the Grand Canyon. These postcards showed the well-known locations and geological formations in the Grand Canyon. The name of each location was written on the postcards, making the locations easy to identify and memorize. These locations included the Colorado River, the Inner Gorge, the Bright Angel Trail, the Kaibab Trail, Vishnu Temple, Isis Temple, Zoroaster Temple, Havasu Falls, and many more. By studying these postcards we memorized the name of each location and learned where they were located in the Grand Canyon.

My fine art photographs featured all of these locations. When customers showed interest in a specific photograph, we told them the name of the locations featured in that photograph. By doing so we helped our customers learn more about the Grand Canyon and we also educated them about the geology and the history of the Canyon. Often, this started an exchange between the customers and us. Customers were curious to find out how we knew so much about the Grand Canyon, how long we had lived there, what brought us there, and so on. Many of these customers ended up purchasing my artwork. They purchased it because the knowledge we shared with them created a bond between them and the photograph. The photograph was more than an image. It was a reminder of the time they spent at the Grand Canyon, of what they had seen and learned, and of our encounter.

Educating your customers and sharing your knowledge creates a bond between you and your clients. It enriches your customers' experience and it will often lead to a sale.

Story 6

Discover Before You Sell

*Opportunity is missed by most people because
it is dressed in overalls and looks like work.*
THOMAS EDISON

The selling process starts with the discovery phase. You discover what people want by asking the right questions.

During a show, one of our competitors, unable to close the sale, gave his business card to the customer and told him to call if he changed his mind regarding buying one of his photographs. Seeing this, and aware that if the customer left the show he would probably never come back, I stepped in and did four things that eventually led to a sale.

First, after introducing myself, I asked the customer if he was ready to buy a photograph today if I was able to find one he liked. His answer was yes. Right off the bat I achieved something that my competitor did not achieve: I discovered the customer's motivation. It did not take very long, and it wasn't very complicated, but I knew how to do it and my competitor did not. Right there I started on the right foot and was on my way to making the sale.

Second, at the same time as I discovered the customer's motivation, I also got a commitment from the customer: the customer told me that he wanted to buy today. This was the real discovery!

Third, I led the customer to a photograph comparable in size and taken from the same location as the one my competitor was trying to sell him. Once in front of this photograph the customer said he did not like the piece. I then told the customer, "You are a smart buyer. This photograph is one of my least popular sellers. I show it because it gets a lot of attention, but most people don't buy it." By revealing this information I gained the customer's trust. By complimenting him I also made the customer feel good about his buying skills.

Fourth, I then led the customer to a second photograph, the same size as the previous one and also of the Grand Canyon, but showing a different location. This photograph was one of my best-selling images. Once in front of the photograph I told the customer, "This is the photograph I am the most proud of. If I had to pick a single photograph for myself, this is the one I'd buy." Again, I revealed private information, thereby building on the trust generated earlier on.

The customer was interested but wanted to negotiate, so I went to talk to Natalie, spent some time with her, then returned to the customer and said, "This is a limited edition and we only have two of these left. I am willing to negotiate, but I can't go much lower because I know I will be selling these two during this show. The best I can do is 10 percent off. I never do this when I get that low in an edition, but I want to help you because I see how much this photograph means to you." The customer agreed to the price I offered him and bought the photograph. There was no need to lower the price by more than 10 percent because trust had been established and because the customer understood I was expecting to sell it at full price during the show.

Artwork does not sell itself. Artwork is sold by discovering what people want and by helping them find a way to buy it. By doing this, I succeeded where my competitor failed.

Story 7

Bubble Wrap Makes the Sale!

*Don't underestimate the value of beginning a headline
by naming the people you want to reach.*
JOHN CAPLES

It's easy to overlook small but important details when trying to close a sale. The secret to doing it right and to think of everything is to focus your attention on the customer, listen attentively to his or her questions, and make sure to address each area of concern.

When we sell my work we always give customers the option of taking the artwork with them or of having it shipped. Customers who want to take their artwork with them are often concerned with damaging it during their travels or on the way back to their house. Of course we wrap each piece carefully before handing it to the customer, but they don't know that unless we tell them.

At a Grand Canyon show, Natalie came up with the idea of showing an interested but concerned customer exactly how the artwork would be packed. She took the piece and placed a sheet of cardboard on top of the glass, wrapped the piece in several layers of bubble wrap, taped the bubble wrap so it was securely fastened around the frame, and then put the package in a large plastic bag. When she was done the artwork was so well protected that it seemed as if one could drop it on the floor and it would bounce right back up!

At first, the customer watching Natalie's demonstration was suspicious of the efficiency of her packing approach. This is normal because customers have no idea how we pack artwork. However, as the packing process progressed toward its conclusion, the customer's suspicion turned to satisfaction and eventually to excitement. By the time the packing was completed, the customer reached for the package to feel how thick and secure the packing was. The customer then handed over a credit card. There was no need to close the sale. The bubble wrap had done it!

Don't overlook what may appear to you as small details. Your customers are not aware of the things you do routinely. Telling them about it is nice, but showing them how you do it is even better. When you do, you will have similar experiences, situations where something as mundane as bubble wrap makes the sale.

◄ *Fall Colors Along Canyon Wall, Zion National Park* © Alain Briot

Story 8

Show It In a Bin

Luxury has two value facets—luxury for oneself and luxury for others.
To sustain the latter facet it is essential that there should be many more
people that are familiar with the brand than those who could possibly
afford to buy it for themselves.
JEAN-NOËL KAPFERER AND VINCENT BASTIEN

Customers love to browse through bins filled with prints. We learned this the hard way! When I started selling my work, I did not have any show equipment. No print bins, no easels, nothing. The first shows I did provided tables or display panels, and I either laid my photographs on one of the tables or hung them on the panels.

At one of these early shows, I had a competitor who used floor-standing poster display bins to present his photographs. This was the first time I saw such a bin. These are about waist high and can hold up to 20 or more prints. This setup makes it easy for customers to flip through the prints while standing in front of the bin.

At first I thought this approach to displaying prints was ineffective because from a distance you could only see one print, the one that was in the front of the bin. But as the day went by, I saw customer after customer go to this bin, as if attracted by a magnet. They would browse through the prints, pulling some out to study them more closely, putting some aside, rearranging them by placing their favorites to the front, and eventually making a purchase. Many bought more than one print. Some even built small collections of images they intended to display together. As I witnessed this, my initial suspicion about the effectiveness of this approach was replaced by an intense desire to own and use one of these bins myself.

At the next show I had a bin similar to the one my competitor was using. It worked just as well for me as it did for him in regard to making sales. Furthermore, having my own bin taught me even more about the power of bins because I learned things I did not notice by looking at my competitor's bins. For example, even though each photograph featured in my bin was also displayed framed on the wall, customers preferred rummaging through the bins rather than looking at the framed photographs on the walls. Some even asked me to frame a photo they

had found in the bin, unaware that a framed version was available next to them.

I had become a bin freak. Bins made customers spend more time in my booth, and the longer a customer stayed, the more they bought. Seeing that, I increased the number of bins I had in my booth. At the following show I had two bins, at the show after that I had four bins, and at the next one I had six bins. By the end of the season I had ten floor-standing print bins in my booth.

Having that many bins meant that multiple customers could browse through my photographs at the same time. Ten bins meant ten customers could browse through the prints simultaneously. Of course there was a limit as to how many bins I could use—I had space limitations—but having multiple bins generated far more sales than having just one or two. An important reason for having a large number of bins was that if all the bins were taken, incoming customers would walk away and buy from another vendor instead of me.

Having multiple bins also allowed me to place different-sized prints in different bins. I had bins for 8×10s, bins for 11×14s, and bins for 16×20s. I even had a bin for 20×30s, although this size was almost too large for the bin. Regardless, I sold prints in all these sizes out of these bins.

Having print bins filled with a large number of prints in several different sizes is attractive to prospective buyers. This is because browsing through a bin is less intimidating than comparing framed pieces displayed on a gallery wall. Customers can make their selection themselves instead of having to ask a salesperson to show them a specific piece.

Bins filled with loose prints provide an opportunity for potential buyers to browse through the images in a relaxed manner. It gives customers a chance to make physical contact with the artwork because they can handle the artwork themselves. Bins also promote a direct and personal involvement with the artwork, which fosters sales and encourages customers to buy multiple prints.

Story 9

Anger – Don't Feel It

Anger is an emotion related to one's perception of having been offended or wronged and a tendency to undo that wrongdoing by retaliation.
SHEILA VIDEBECK

Anger: don't feel it. I remember seeing a sign with this statement in a used car dealership in Los Angeles where I went to resell my Ford Pinto in 1983. I was angry at the low price the dealer offered me for the car and when I saw the sign I understood why it was there. Probably a lot of customers felt the way I did. The sign made me feel better because it showed me that I wasn't the only one in this situation. It also helped me agree to the deal because the car probably wasn't worth much more than what the dealer offered me.

For a long time I wondered what was meant by "don't feel it." Here is how I have come to understand the meaning of that phrase: you can always say no to a deal, whether you are selling a car and getting next to nothing for it, or whether someone is making an unacceptable offer for your work.

When you are selling your work you do not have to accept a deal that is insulting to you. In short, you do not have to feel insulted. You can simply refuse to accept what you consider unacceptable. If you do, you will not feel angry.

On the other hand, if you do agree to the deal, do so willingly. Here too there is no need to be angry. You are in control of your decision; you could have said no to the deal you were presented with. If you accepted it you must live with the consequences of your actions.

Anger often comes from believing that we are being wronged and that we have no control over what is being done to us. In such situations the tendency is to retaliate. This is the wrong reaction. Certainly, we do not have control over what other people are doing. We cannot prevent someone from making a ridiculously low offer for our work, for example. However, we do have control over how we respond to the offer. If accepting the offer makes us angry, it is better not to accept this offer. We do not have to agree to unacceptable demands. We can simply say no and walk away. Whatever we do, we must not let anger control us. Only bad decisions are made when we get angry.

When responding to an offer you find offensive, getting angry is not helpful. Always remember that in business the goal is to be helpful, not to be right.

Sunrise Reflections, Bosque Del Apache, New Mexico © Alain Briot ▸

Therefore, instead of getting angry, help the customer understand why you cannot accept the offer. Explain why you cannot sell your work for the amount offered. By doing so you may be able to negotiate a price that is agreeable to both of you. If you cannot reach an agreement, that's OK too because you cannot close every single sale. Sometimes not making a deal is the best deal you can make!

Story 10

Personalize It to Sell It

Create a definite plan for carrying out your desire and begin at once,
whether you are ready or not, to put this plan into action.
NAPOLEON HILL

Having an artist present in person at a gallery or show, personally dedicating his or her artwork, is one of the most powerful selling points in the world of fine art.

Early in my career, one of my customers asked me if her friend could take a photo of me and her, one of us on each side of the artwork she purchased, holding the framed piece between us. She also asked me to dedicate the piece to her, personalize it with a special statement on the back of the piece, and sign it a second time.

I obliged her and she was so thrilled that she purchased a companion piece. This was the first such request I had ever received and I was surprised by how something as simple as dedicating the piece and having my photo taken had generated such excitement.

However, as I continued to sell my artwork personally at shows, I soon learned that personalized artwork and having a photo taken with the artist were highly valued by customers. These things cost me nothing, but they helped sell larger pieces and closed many sales that would otherwise have not been closed.

Over the years countless customers have asked me to dedicate the artwork to them and take a photo of me and them holding the artwork they purchased. Because this is such a popular request, I started mentioning to customers during the buying process that I do this. I do so quietly by saying something like, "When you invest in this piece I will be pleased to dedicate it to you. Maybe there is something special you'd like me to write? We can also take a photograph of me and you holding the artwork if you want." I also mention that there is no cost for this service, and that the reason I can do it is because I am present at this show.

Many times, offering to personalize my artwork makes the difference between the customer saying, "I'll think about it" and, "I'll take it." It is particularly appreciated when I am creating a custom piece for a customer, one that will be shipped to them at a later date. Doing so gives my artwork added value and meaning in the eyes of the customers who will be receiving it. It also gives them

something to brag about to their friends. After all, not everyone gets to meet the artist in person, have him personally dedicate his work to you, and agree to have his picture taken with you and the piece that now hangs in your living room. In addition, when the time comes to authenticate the work, the photograph of the customer with the artist and the piece purchased from him provides evidence that the work is authentic.

Personalizing and dedicating your artwork increases its value in the eyes of your customers. It also justifies your prices, helps close the sale, and maximizes your leverage for being there in person at a show.

Story 11

Uniqueness Sells

You will make a lousy anybody else,
but you will make the best "you" in existence.
ZIG ZIGLAR

C ustomers like to buy artwork that is original, different, and unexpected. The unique aspects of your work are some of your most important selling assets. To achieve this you will need to work hard at developing a personal style. Having a style based on your vision for your work will make you unique and give you an edge that no competitor can ever take away from you.

There are many ways of developing a personal style. This can be achieved through your selection of subject matter, the type of compositions you favor, or the use of a specific color palette, for example. However, you can also develop a personal style by creating a unique matting and framing style.

Living on the Navajo Reservation inspired us to create artwork that featured a unique matting style. Instead of offering photographs matted in plain white mats, the way photographs are traditionally presented, we decided to create mats with Southwest designs and Southwest-inspired decorative elements.

On the Navajo Reservation we bought a variety of décor items made by jewelers, craftspeople, and artisans. Doing so was easy because we lived there. We knew where to go and whom to buy from. In fact, many of the artisans we bought items from were friends, and purchasing from them helped them as much as it helped us.

These décor items included bear fetishes, modern-made stone arrowheads, sterling horse pendants, pieces of turquoise, turkey feathers, bone carvings, beaded items, and more. These were all made by Native Americans, which provided added value and significance. We used these items to decorate our matted photographs of the Grand Canyon, Canyon de Chelly, Antelope Canyon, and other locations in Navajoland and in the Southwest.

The photographs were double-matted in beige and dark brown. We chose these colors and decorations to give the artwork a Southwestern feel. The mats were cut with intricate Southwest corner designs called *palomino*. At first I cut the mats by hand, but because of their complexity I could only cut one or two a day. To remedy this problem we bought an Eclipse computerized mat cutter, and

this made cutting these intricate designs a breeze. With it we could cut hundreds of mats a day and the machine was never tired. It cut just as well in the evening as it did in the morning! The first mat was perfect and the last mat was perfect. The computerized mat cutter was the perfect employee. Not only did it never get tired, it did not complain, did not get sick, and was at work on time every day. It did not ask for a raise, for medical coverage, for unemployment benefits, or for anything else. It also gave us a huge advantage over our competitors. We were the only ones able to cut such intricate mats because we were the only ones to have a computerized mat cutter. We were also able to offer these mats at reasonable prices because cutting them was fast and efficient.

These decorated, matted photographs were each unique because no two décor items were exactly the same. Often, an artisan would create a specific item for a while, then stop and never produce it again. We made sure to explain this to our customers so they knew that each piece was unique. We also told them that if they liked a specific piece they needed to buy it now, because once it was gone we could never make the same exact one again. These decorated mat pieces sold extremely well and we never had enough of them in stock!

We also included an information label on the back of each mat. This label featured information about the photograph and the décor items displayed in the mat. These labels were simple: just text printed on white paper. What was important was the information written on them. Here is an example of the information label we added to the artwork:

NAVAJO HOGAN

This hogan is located in Canyon de Chelly and was photographed during the fall when the cottonwood trees turn bright yellow. The hogan is the traditional home of the Navajo people. Hogans are made of juniper logs partially covered with earth. The earth coating provides good insulation from both heat and cold. The doorway of a hogan always faces east to receive the blessing of the day's first light.

The decorations and their meanings:
- The feathers are symbols of prayers, sources of ideas, or marks of honor.
- The turquoise protects the wearer from harm and brings good fortune. Turquoise helps you to stay in a place of love and connectedness with others.
- The bear fetish represents physical strength, introspection, and leadership.
- The stone arrowhead is handmade. Native Americans used arrowheads for hunting and for protection.

For customers who preferred a traditional fine art presentation, we continued to offer photographs matted in plain white mats. Offering these two different presentations meant that we had something to offer to both audiences so did not lose our previous customers. Instead we expanded our audience by offering something that pleased both categories of clients.

Don't sell on the basis of price; sell on the basis of uniqueness. If customers come to you because of price, they will leave you because of price. If customers come to you because of uniqueness, they will continue buying from you because of uniqueness.

Story 12

Light Sells the Art

Never spend your money before you have it.
THOMAS JEFFERSON

L ight sells the photograph; therefore, show your artwork under the best lighting possible.

We discovered the importance of good lighting the hard way. When I started selling my work I did not pay much attention to lighting. What was important to me was the artwork, not the light shining on the artwork. But we soon realized that good artwork in poor light doesn't look very good. In fact, it doesn't look good at all! Artwork, and photographs in particular, need good lighting to look their best. With poor lighting photographs look dark, the colors look desaturated, and the details in the image can't be seen. The overall impression is one of a dull and uninteresting image, regardless of how the photograph may actually look and how hard you worked on making the colors and contrast absolutely perfect. In short, your hard work will all be for nothing if you don't have good lighting.

Before Natalie and I understood how important good lighting is we would take customers in front of a specific photograph, and we would praise the quality of the photograph to them. "Look how saturated the colors are! Look how much detail you can see in the shadows!" we would say. But our excitement did not carry over to our customers because they could not see for themselves what we were telling them. We knew how good the photograph actually looked because we had seen it under perfectly calibrated lighting in my studio. However, once at the show the same photograph was displayed with dismal lighting that did not do it justice and did not allow the customers to see it for what it truly was. The outcome was that even though customers were interested in the work and liked the photograph, the lack of lighting often prevented us from closing the sale.

Before I started using good lighting I found a solution to this problem, but it only worked in specific situations. During outdoor shows, when a customer showed interest in a photograph I would take it off the wall, carry it outside of my booth, and show the artwork in direct sunlight. This not only showed the work in very good light, it also removed reflections, making it possible for the customers to truly enjoy the artwork and to see it in the best possible way.

Showing the work that way always generated oohs and aahs from customers. If they liked the photograph in poor light, they truly loved it when they saw it in direct sunlight. I would tell them about the image, where it was taken, at what time of day (sunrise or sunset), at what time of the year, and much more. Afterwards, all I needed to do to close the sale was ask, "Do you want to take it with you or do you prefer to have me ship it?" I would continue holding the artwork in direct light until I had an answer. Sometimes, if it was a couple, they would exchange a few words between the two of them before saying, "We'll take it!" or, "Can you ship it? We just don't have enough space to fit it in our car." I would then walk back to my booth, place the piece on my worktable, and write their receipt.

Because showing the artwork in direct sunlight is such an effective technique, I continue to use it to this day even though I now have excellent lighting. However, to be effective it requires that the sun is shining and that you are doing an outdoor show. If those conditions are not met, you must rely solely on your show lighting.

Good lighting is essential to a successful selling display because it enables you to show the colors of the artwork accurately and brightly. This lighting must be powerful, targeted to each individual work of art, and able to cover the entire surface of each piece evenly. If possible, it should also be calibrated for daylight so the piece will look the same when shown under artificial light and when shown under direct sunlight.

Story 13

Competitors

Some people find fault like there is a reward for it.
ZIG ZIGLAR

Don't run your business by looking at your competition. Focus on your business, not your competitor's business!

When we started selling my work we did not know what we were doing. Our marketing was nonexistent and "salesmanship" was not in our dictionary. As a result, our sales were rather slow, to say the least.

There were always two artists showing at the same time on the north porch of the El Tovar Hotel at the Grand Canyon, the location where we sold my work at the time. While there were a number of different artists, we often found ourselves paired with Mark, another photographer. Mark had been doing this show for over 15 years and he knew every trick of the trade. He knew what people wanted and he knew how to motivate people to buy from him. His marketing was excellent and his salesmanship skills were second to none.

The El Tovar show was divided in two halves, one on each side of the path leading to the hotel entrance. One side was twice the size of the other side. Mark always had the larger side. This allowed him to display far more work than we could, and attract many more customers. On top of that he had huge pieces, up to 50" × 60", while my largest piece was 16" × 20" frame size.

As a result, Mark's sales were through the roof while ours were few and far between. Not knowing any better, when business was slow for us (which, at the time, was often) we would sit down and watch as Mark made sales. Needless to say, this was a depressing exercise, and the more sales Mark made the more depressed and dejected we became. Nothing saps your energy like watching another artist do well while no one buys from you. A full day of this, to say nothing of several days or even a week, since the El Tovar show lasted a week, and you have nothing left. You feel worthless and you are physically and emotionally beat down.

However, we soon realized that watching Mark's success wasn't going to make us any more successful. In fact, watching him sell prevented us from trying to sell my work! Some customers did come to our booth to look at my work, but we were so engaged in watching Mark do his thing that we did not pay attention

to them. In fact, the more we watched Mark, the less we paid attention to the customers who were in our booth and who looked at my artwork.

I am not one to pity myself any longer than I have to. Therefore, we decided to focus on our business, no matter how slow it may have been, rather than on Mark's business, no matter how busy it may have been. The amount of money Mark had in his pocket at the end of the day was of no consequence to us. Knowing how much he made was not going to make us any wealthier. At the end of the show, it is how much money we returned home with that mattered, not how much money Mark returned home with.

As soon as we took our eyes off our competitor our sales went up. Instead of watching Mark, we focused on the few customers who visited our booth. We said hi to them, we asked them if this was their first visit to the Grand Canyon, we asked them how long they were staying, and we asked them where they were from. In other words, we engaged them by asking questions. How did we know what to ask them? By watching Mark! We simply asked the same questions Mark asked. If these questions worked for him, they should work for us too. The secret was in the questions, not in who asked the questions.

Mark became our teacher. Instead of watching him and getting discouraged, we started watching him to learn how to do what he did. We started by learning which questions to ask, we continued by learning what selling process he followed, and we concluded by learning which closes he used. Our competitor became our teacher. Don't blame me for learning that way. I had no choice. The alternative was to watch him make a fortune while we got more and more depressed. If I had gone that route I would not be here today telling you this story. I would have quit, discouraged by Mark's success and by my lack of sales.

Don't be obsessed by your competitors. Let them do their thing. Remember that what matters is how well you do, not how well they do.

Story 14

Make Your Customers Feel Comfortable

Money is the most effective means of keeping score.
DAN KENNEDY

Making a decision to purchase art can be difficult. Making your customers feel comfortable will help them make positive decisions regarding purchasing your work.

We always greeted everyone when they walked into our booth at the El Tovar Hotel in Grand Canyon National Park. In the morning, people were rested and ready to get going for the day, so we just chatted with them while they stood in front of us. They usually took a look at my work, told us they would be back later on, and then started off on their sightseeing schedule for the day.

In the late afternoon the same people often returned to our booth, after a long day of seeing the sights. Most of them had spent hours walking along the rim and some had hiked partway down one of the trails that lead into the canyon. Needless to say, by the time we met them they were tired and thirsty and needed a break.

Most of them were interested in taking a second look at my work, as they mentioned in the morning, but we could see that walking all day long had taken a toll on them. After looking at a couple of pieces they showed signs of exhaustion and were ready to leave without making a purchase. This is when we stepped in, aware that we could make or break the sale depending on what we did next.

There was a huge bench on the porch of the El Tovar Hotel. During the day we used this bench to store supplies, organize prints, and conduct other business activities. However, in the afternoon we made sure the bench was empty so we could offer our customers a place to sit and take a break. We also offered them bottled water to drink. We actually brought bottled water to the show for this purpose. We never had anyone turn us down; everyone was thankful for the opportunity to rest and have a drink of water.

Because making sales was our goal, we displayed our largest and best-selling panoramic photograph of the Grand Canyon right in front of the bench so that clients could look at it while they sat down and relaxed. For many, this was the

◄ *Alabama Hills, Eastern Sierra Nevada* © Alain Briot

piece they were considering purchasing. While they relaxed, we told them where the photograph was taken, what was unique about it, and how I created it. After we talked with our visitors we left them alone so they could talk to each other and make a decision.

Most of the time, being seated, having a drink of water, and relaxing while admiring a beautiful photograph of the Grand Canyon did it. More often than not the answer when we asked for the sale was "We'll take it!" Making our customers comfortable, letting them relax and catch their breath after a long day of sightseeing, and giving them an opportunity to reflect and make a decision had sealed the deal.

Being comfortable makes it much easier to make decisions. Providing seating and refreshments to your customers creates a relaxing environment that is propitious to sales. Customers who feel good working with you will not only buy from you, they will often make larger purchases than if they feel tired, rushed, and uncomfortable.

Story 15

Artist Statement Stories Sell

Advertising is the life of trade.
CALVIN COOLIDGE

Having an artist statement is important. Even more important is the content of your artist statement. Featuring stories in your statement helps you sell your work because stories show who you are to your customers. In the artist statement I used at the El Tovar show in Grand Canyon National Park, I included stories with a touch of humor. My artist statement was framed and displayed in a prominent spot in my show. It was often one of the first things visitors noticed when they walked into my booth.

Using humor in my stories made me come across as approachable and friendly to people who had not yet met me. It made people feel confident that they could come to me to say hi and that they would get a friendly response from me. The stories and the humor featured in my statement made the point that I was easygoing and friendly. I was not a prima donna, and I did not have a huge ego. Instead, my writing shared the fact that I looked at my artistic life with a touch of humor and with some irony.

Clients who came to talk to me often started the conversation by mentioning how much they enjoyed reading my artist statement. Many mentioned that they could relate to the stories I included in that statement. Even though this was the first time we saw each other, my stories created a bond between us. Sometimes, after reading my stories, customers found something we had in common, something we had both experienced. The stories worked as icebreakers that allowed us to start talking and to get to know each other. Our conversation was lighthearted and fun. We laughed, we enjoyed each other's company, and we talked about what I said in my stories as if it was something we had experienced together.

When we caught our breath I suggested they take time to look at my work then come back and tell me which of my photographs was their favorite. When they came back and told me which photograph they liked the most, I explained how this particular image was created, adding another story to the ones they had read in my statement. This further strengthened the bond we shared. More often than not, this exchange led to a sale.

People enjoy listening to stories. In many ways it is one of the things that make us human. People have told each other stories since time immemorial. It is one of the fundamental ways through which we learn new things and get to know new people.

Sharing stories about yourself creates trust. It also creates a bond between you and your customers. Even if you just met, when you tell stories about yourself to customers they feel like they have known you for a long time. It makes them feel confident that buying your work will be a positive experience. Plus, they can tell the stories you shared with them to their friends and relatives. Doing so will add significance to their purchase and make it stand out as an important event in their lives.

The artist statement I used at the Grand Canyon is featured below.

ARTIST STATEMENT
PARIS PAINTER AND PHOTOGRAPHER ALAIN BRIOT
CREATES ARTISTIC PHOTOGRAPHS OF THE AMERICAN WEST

Originally from Paris, France, I have been creating art since my early childhood. My original formal training was as a painter. From 1977 to 1980 I attended the Academie Nationale des Beaux Arts in Paris, where I studied drawing, watercolor, and oil painting. After graduating from the Beaux Arts I studied with master photographers at the American Center in Paris from 1980 to 1983. My teacher, Scott McLeay, taught me fundamental photographic practices that I still use today. Through his teaching he emphasized the importance that composition plays in successful photographs. The quality of the light was of utmost importance to him, and he constantly stressed how valuable it is to understand which light one likes to work with. The result is that I am now creating photographs using what I call **ultimate light,** which adds depth and brilliance to each image I create for you. The more depth and brilliance, the more three-dimensional the image appears and the more enjoyment you receive from it.

In 1983 I traveled throughout the Western United States for six months and photographed the Grand Canyon for the first time. I worked with an Arca Swiss 4×5 view camera, photographing mainly in black and white and following the tutorial of Ansel Adams. The landscape of the American West both surprised and amazed me. However, as I became aware of the unbelievable potential it had in store for an artist I also understood that more than six months would be needed to do it justice.

In January 1986 I was accepted as a freshman at Northern Arizona University in Flagstaff, Arizona. I chose to study at NAU because it is located only 75 miles from the Grand Canyon. Living in Flagstaff allowed me to live near the landscape that so

enthralled me during my first visit. It also allowed me to continue the work I started in 1983 with much more time available to me now that I lived here.

Today, I devote most of my time to photographing the Grand Canyon and the Southwest. I look for the best composition, the perfect foreground, and wait for the **ultimate light**. My goal is to create spectacular photographs that will add a beautiful touch to your home or office.

My academic studies complement my artistic work. Centered on the history of landscape photography, my studies allowed me to investigate the endeavors of the first photographers to venture in the American West as well as the importance of their contribution to photography as a form of visual communication. I received my bachelor's degree in 1990 and my master's degree in 1992, both from Northern Arizona University. The knowledge I acquired during my studies allows me to give a historical dimension to my work as well as locate my work within the tradition of Western landscape representation.

In 1992 I moved to Hancock, in Michigan's Upper Peninsula, to work on my Ph. D. at Michigan Technological University. The Upper Peninsula provided me with an opportunity to discover the fascinating landscapes of the Upper Midwest and the Lower Canadian Shield. We lived only a few miles from Lake Superior and I became fascinated by this immense inland sea, this massive body of soft water that I had heard much about but never seen before. I was shocked by the strength of the seasons that followed each other with no apparent connection among them. To a soft and delicate spring succeeded a summer overflowing with vegetation spanning all colors in the green spectrum and filled with swarms of mosquitoes. Fall appeared one morning after a cold spell and surrounded us with rusts and yellows for what seemed to be a short weekend. Then winter came and for those who have lived in the Upper Peninsula there is little need to say more. For me it was a total shock from which I emerged six months later somewhat bewildered by the relentless snowstorms, the never ending cold, and the discovery that cabin fever was a reality and not just an element of Jack London's novels.

Since 1983 my artwork has been intimately tied to the national parks. Besides working extensively in many national parks, I was selected as artist in residence at Isle Royale National Park, Michigan, and at Apostle Islands National Lakeshore, Wisconsin, in 1994. I have been exhibiting and selling my work at Grand Canyon National Park since 1997.

From 1995 to 2002 I lived in Canyon de Chelly, Arizona, in the heart of the Navajo Nation. This location gave me intimate access to some of the most impressive landscapes in North America and allowed me to photograph Native American rock art. In 1998 I received the Oliver Award for excellence in Native American rock art photography from the American Rock Art Research Association. This national award

is given to a single photographer each year. My knowledge of Native American arts and culture is passed on to you through the frames and the matting designs I select to make my work even more enjoyable.

In December 2002 I moved to Peoria, Arizona, in the Sonoran Desert region. At this time I just completed this move and I am just starting to explore the new possibilities that are offered to me. I am excited about working and photographing in a new area and I look forward to creating stunning images of the Sonoran Desert. This move also brings new opportunities for you, such as workshops and exciting publications that will be announced throughout the year on my website (www. beautiful-landscape.com) as well as on Digital Outback Photo (www.outbackphoto. net) and Luminous Landscape (www.luminous-landscape.com).

Today I find inspiration in the work of artists ranging from Thomas Moran to Ansel Adams. This blend of inspiration, coming from both the American tradition of landscape painting and of landscape photography, is mirrored in my own training, which began as an oil painter at the Beaux Arts in Paris and is continued today as a landscape photographer in the United States. I see myself as an international artist, influenced by traditions that find their roots deep in Europe and in the United States.

Decorate your home or office with beautiful photographs of nature

My goal is to create artwork that you will find both inspiring and enjoyable, that will become a family heirloom, that will bring back wonderful memories, and that will generate endless enjoyment each time you admire it in your home. Which one of my photographs is your favorite? Which one are you going to display in your home or office?

Don't forget to email me

I answer each email personally and usually within a day unless I am away. Send me your questions or your feedback. I look forward to hearing from you!

<div align="center">

alain@beautiful-landscape.com

www.beautiful-landscape.com

Alain Briot • PO Box 12343 • Glendale, AZ 85318

800–949–7983 or 928–252–2466

</div>

Impressionist Joshua Tree Sunrise © Alain Briot ▶

PART 2
EIGHT ARTISTS:
IN THEIR OWN WORDS

Introduction to Part 2

This section features the marketing approaches used by eight different photographers. These photographers focus on a broad array of subject matter and live in a variety of locations, both in the United States and abroad.

Each chapter starts with a background information section in which I describe the selling approach used by each artist. I also explain the positive aspects and the shortcomings of their approach.

Each chapter continues with the artist describing in their own words their marketing approach and other insider tips related to their businesses. As you will see, these descriptions are each unique. They also offer interesting insights into the reasons why each artist made specific marketing decisions.

Finally, each chapter concludes with a set of Skill Enhancement Exercises. These exercises are designed to help you reflect on what you learned and make decisions regarding your own marketing approach.

◄ *Aspens in Snowstorm, Northern New Mexico* © Alain Briot

60

PART 2
..
STORY 1 MAGGIE LEEF: SELLING WHOLESALE TO RETAIL STORES
..

Story 1

Maggie Leef:
Selling Wholesale to Retail Stores

Background

Maggie Leef focuses on fine art photographs of the American Southwest, and especially in Arizona, where she lives. She creates a variety of photography products, such as fine art prints, calendars, cards, magnets, and bookmarks, and sells them wholesale to several stores. The stores then resell her products at retail prices.

The positive aspect of this approach is that it frees her from having to sell her work herself in a retail location such as at an art show, a personal gallery, or on a website. Selling wholesale to stores is less time-consuming than selling retail yourself.

However, this approach has its shortcomings. For one, you usually get paid on net 30 days terms, meaning 30 days after you deliver the products to the store. You also are limited in what you can sell. Typically, fine art does not sell well in retail stores, which is why Maggie added calendars, note cards, magnets, bookmarks, and other products to her fine art prints.

In Maggie's Own Words

Description of Selling Venue
My primary selling venue is wholesale to stores and museums, and to organizations for special events, such as wildlife festivals and local celebrations. I also sell my artwork in galleries and shows, and I teach workshops on photography, wildlife, and other subjects.

How I Started My Business
Though I'd done photography all my life, I started my business in 2005 after I went digital and discovered the joys of image editing. The instant feedback and creating designs and special effects were so exciting! I could finally visually express the emotions I felt and I wanted to share this with others. I wanted people to look

Aspens in White © Maggie Leef ▸

Maggie Leef

at my work and say, "I've been there!" or, "I want to see that!" I wanted to touch their creative or spiritual selves the way I was touched when I was out in nature.

I registered my business name with the state and got state and federal tax numbers and business licenses. My first wholesale products were note cards and postcards featuring local scenes. I sold my artwork at shows and galleries, and I also created outdoor portraits and did photo restoration. In 2010 I narrowed my business focus, added wholesale prints, and began to greatly expand my product line.

What Works and Doesn't Work in Regard to Marketing

For marketing my products, I've used magazine and email ads, flyers, posters, postcards, banners, local TV and magazine interviews, personal appearances, public presentations, a gift show, and websites. While all these gave me visibility, what has worked best has been establishing good relationships with individual buyers and offering them something that they couldn't get elsewhere. What I offer that's unique is my artwork on products with the option of adding the customers' business logos and customized text. I can feature others' images or even historical images on products, as long as I have copyright permission. I charge a reasonable design fee.

What doesn't work is getting published frequently, establishing good name recognition, and waiting for customers to appear. Initially, I thought that by doing

these things people would see my work and want to buy it. They did want it, but primarily in the form of donations for their fundraising events, publications, and websites.

Recommendations for Photographers Who Are Starting to Sell Their Work

I suggest you first do an informal market survey. Visit the stores you want to do business with and check out their product lines. Then try to find products that not everyone carries, or if they do, find products that you can make unique in some way. Talk to store owners and see what they need or want. Some good sources for product ideas are Museums & More (museumsandmore.com) and magazines like *Giftware News*. Also, visiting trade or gift shows can be invaluable. Offering new, quality products on a regular basis helps to keep retailers' interest and lets them know that your business is expanding and evolving.

For supplies and packaging I've used ClearBags (clearbags.com) for years. For portable displays or show supplies I like Store Supply Warehouse (storesupply. com). For puzzles I like Heads Up Puzzles (headsuppuzzles.com). And don't forget professional photo labs, many of which also offer customized products. If you mainly order products after a customer has ordered them from you, you'll have a very low inventory and storage won't be a problem. If you don't customize but instead buy your products in volume, you'll make a larger profit but will need more storage space. I recommend that you put together a sample box that you

can carry with you. Just keep a few extra items on hand in case a prospective customer wants to borrow products to show to an off-site supervisor.

Selling wholesale is difficult. The profit margin is small and you'll spend at least 50 to 60 percent of your time on marketing. You'll spend additional time ordering products and then unpacking them, doing inventory, and then repacking them for delivery. Occasionally you'll have to spend lots of phone time with company representatives straightening out problems. Products are sometimes received late or may not be what you expected. If your suppliers don't offer flat shipping rates, the shipping costs are high. You'll need additional sources of revenue through other types of sales.

It is exhilarating, though, to see a product come to life as you imagined it. It's exciting to open boxes of quality products and know that your customers will be pleased. I like operating a photography business because I enjoy sharing my vision

and inspiration with others. I express myself through my work. I create art that speaks to me, and I sell products that I like and would like to buy. I recommend that you do the same.

Contact Information
Website: www.leefphotography.com
Email: mountainhiker_80@hotmail.com

Skill Enhancement Exercises

What do you like in Maggie's approach to marketing her work?
What do you not like in Maggie's approach to marketing her work?

Make a list of what you see as being the strong and the weak points of Maggie's marketing approach. Once that list is complete, decide what you can use from this artist's approach and write answers to the following questions:

- ❯ What do you see as being useful for your own marketing approach?
- ❯ What do you see as not being useful for your own marketing approach?
- ❯ Is there anything missing from this artist's marketing approach? If yes, what is it?

66

PART 2
...
STORY 2 BILL IRWIN: HOME GALLERY SALES
...

Story 2
Bill Irwin: Home Gallery Sales

Background

Bill Irwin sells his fine art photographs of Australian landscapes in his home gallery. The main advantage of this approach is the low operating costs. Instead of having to rent gallery space, Bill makes use of existing space in his home to display his work. This saves commuting time and costs, rental fees, and utility expenses. It also saves Bill from having to hire one or several employees. Typically, a home gallery sees less traffic than a street gallery, allowing the owner to operate the gallery by appointment and to conduct other activities when there are no gallery visitors, such as printing, processing, paperwork, and so forth.

The negative aspect of this approach is you must have name recognition, at least locally and preferably globally, to make this approach successful. People must know who you are in order to call you, make an appointment, and visit your gallery. They cannot happen upon your gallery by accident the way they would if your gallery was located in a busy tourist location, for example. Because clients must make an appointment, this approach requires careful planning and logistics on their part and yours.

What all this means is that you will have far fewer customers in a home gallery setting than you would in a street gallery setting. Therefore, to compensate for the small volume of sales, your prices must be more than adequate (read "high") in order to generate a desirable level of income.

In Bill's Own Words

My Photography

Ten years ago I decided to turn my photography from a hobby into a full-time career, which was an excellent decision for job satisfaction but not the easiest way to earn an income. Work that I love and work that pays well tend to be

Clearing Storm, Lindis Pass © Bill Irwin ▸

Late light, Glenfalloch

Glenfalloch Station is far up the Rakaia River, way back in the hills. It is one of my favourite places to be with its beautiful isolation. Chas and Dietlind, the owners, have given me a lot of help accessing these amazing views. One small hill on the property is called 'the Whale's back'. Just up river from here Lake Stream splits off the Rakaia, running down to the top of Lake Heron.

Sitting on top of the Whale's back one evening around Christmas 2009, I watched some pretty amazing light happen. As the last of the light cut through different valleys slivers of sun streaked through to the riverbed. The sheep grazing on the hill seemed unmoved but I knew I was very lucky to be there.

The print

The print has been made on Canson Rag Photographique, a 310 gsm cotton rag paper, using Ultrachrome K3 pigments. This produces an original print that faithfully reflects the photography; has wonderful feel and is of the best available archival quality. Framing under glass is the ideal presentation.

Bill Irwin

I am a full-time photographer living in Methven. The literal focus of my photography is to make images that celebrate the beauty all around us. We can be caught up in the frantic nature of daily life and miss appreciating the surrounding beauty, always present but often overlooked. I see this beauty both in the landscape and people. I do not believe photography does or should only record 'reality', rather I think that a photographer like any artist should be able to use any tools in the box to create images that resonate with them. I like to think these images are an antidote, a sort of visual anti-depressant, to all that is not right in the world.

From an early age – 10 years old – I have been interested in photography. I was side tracked for 20 years as a farmer, but those years were part of building my appreciation and understanding of the landscape and random beauty of nature. It was only when I made the jump to being a full time photographer and completely immersed myself that my photography grew. Being in a visual mode all day, every day, continually opens up new ways of seeing.

A beautiful image is nothing without a beautiful print. I could never trust this work to a lab, it is as personal as the initial capture. The look and feel of a gorgeously textured, heavy cotton rag paper is wonderful.

Thank you for your interest in my work.

Bill Irwin, ANZIPP
119 Forest Drive, Methven
(03) 302-9905 ~ (027) 464 0052
bill@billirwinarts.com
www.billirwinarts.com

billirwinarts.com

mutually exclusive. My photography consists mainly of rural landscapes, with occasional photographs of individuals (I avoid groups, weddings, etc.). Some work is commissioned for commercial use, but most projects are self-commissioned for images to sell as fine art prints, stock images, or to publish in some form (I have done one book and several calendars). I have spent a lot of time learning how to make excellent prints, currently with an Epson 9800, through the ImagePrint RIP onto cotton rag papers and canvas, mainly from Canson and Hahnemuhle.

Like most artists, marketing and self-promotion does not come easily. Just producing beautiful images, printed superbly, is not enough. Educating people about why they should buy my photographs is a skill I am continually refining.

I live in a small rural town that is a service center to a large ski field on the South Island of New Zealand. There is an influx of visitors for three months over the winter, but the rest of the year it is quiet. It is a great place to work from as a landscape photographer, but not ideal to sell from because most of the year there are not many people around. We thought seriously about moving to a more touristy location, but for family and other reasons we decided to stay here. This dictates my market.

While I initially aimed for passing tourists, I have found local people are my main market. I live in the middle of beautiful landscapes, and people love seeing their own landscape captured beautifully, as art for themselves or to show off to distant friends.

I aim for people who view photography as art rather than as a commodity. My photography is all about beauty, not necessarily reality—a visual stimulant. People who buy my prints have an emotional response to them and value them more than a straight pictorial record.

Things I Tried That Didn't Work

Displays in Cafés and Shops — Initially, I was happy to find a local café where I could display prints for sale. Some sales did happen, but people go to cafés to eat and visit, not to buy art. I soon realized that all I was doing was providing the café owners with free artwork to decorate their walls. I was still assuming risk for any damage to the prints, and the overall setting was never going to be conducive to higher prices.

Art Galleries — The next step was to get my work into a couple of dealer art galleries. My experience had been that most gallery owners don't do a great job of promoting photography because they don't understand everything that goes into creating a beautiful print. Their clients may spend $3,000 or more on a painting, but photography seems to reach a ceiling well below that.

The second problem with dealer galleries is the sales commission, usually in excess of 40 percent. Combine this with the ceiling on prices compared to paintings and the margin is slim. Galleries like to keep their look fresh, so if prints have sat there for a while you have to swap them with new ones. All the time you are competing for attention with dozens of other artists represented by the gallery. The odds are not good.

Some buyers worry about edition limits. Long ago I decided that artificially limiting prints to console insecure buyers was not a game I wanted to play. I want people to buy my prints because they love the image, not because of perceived scarcity, which I see as a cynical marketing ploy.

Expos and Fairs – I tried selling at a large annual weekend fair where I knew thousands of people would visit. I set up a booth to display and sell my work, the idea being to get a big hit of exposure and self-promotion. It was a huge flop as far as sales went, but the lesson I learned was about who my audience is and how important presentation is. My beautiful prints were devalued by being shown among assorted other products that had no artistic value. Many people stopped by and admired the prints, but they were all after a bargain. Fine art must be displayed in an appropriately luxurious setting.

Things That Have Worked

Publishing – Any photographer who has been published has more perceived credibility than one who hasn't. When switching to full-time photography 10 years ago I quickly built up a good portfolio of local images. I noticed that all the New Zealand scenic books ignored our area, concentrating on the more touristy spots. My home area is full of unspoiled beauty, but not many see it (unless you are a *Lord of the Rings* fan; the Edoras set was built a short drive from where I live).

With a concept for a book, I found a publisher to help me through the process. I was a bit nervous as we needed to print 4,000 copies to get a good unit price; I had to sell 1,200 units to break even. A local newspaper was running a weekly photo competition for their readers and asked me to help judge the entries; I donated copies of my book, *Perspectives: Mid Canterbury,* as prizes. With this exposure I reached the break-even point in three months. I thought the main market would be passing tourists, but the overwhelming support was from locals who were excited to see their own landscape in print. Hundreds—thousands now—of copies have been sent all over the world by locals proud of where they live.

After publishing the book, I tried a calendar, which has now become an annual staple Christmas gift for locals to send to friends. They love showing off where they live and in doing so they spread my photography around the globe. The income isn't huge but I see it as a self-funding marketing exercise that keeps my profile in front of people throughout the year. I coordinate with local schools and charities that sell my calendars for fundraisers. It is nice to contribute to the community while also keeping my profile raised.

Cards and posters are something I have looked at and discounted. Unless you are dealing in tens of thousands, the logistics and margins don't seem to add up.

Public Exhibition – I used a local public venue to put on an exhibit of my favorite local prints. I enjoyed showing people places they knew that had been photographed in ways that made them see their backyards with fresh eyes. The prints were made on beautiful Hahnemuhle rag paper and it was the first chance for many people to appreciate truly fine prints. The comments written by visitors

in the guest book were very rewarding, and local newspapers gave good coverage. The end result was a big boost in local recognition of my photography.

Customer Education – I want people to fall in love with an image, have an emotional bond to it, and want to buy a print. To cement the buying decision, they need to be educated about the unique qualities of my prints that may not be obvious—the time put in to capture and creation, the superb quality of archival pigments on cotton rag paper, and the uniqueness of the images.

Postcards – While I don't sell postcards, I have developed a card with an attached tear-off business card. I was always looking for something to write notes on when sending mail or packages out; these are ideal to jot a short message while leaving the recipient with something that may end up on their bulletin board. I tend to leave a few in many places I visit. It is hard to measure how much interest these cards generate but the cost is minimal and they serve a practical purpose.

| Main | Landscape | People | 'Home' exhibit | Blog | Bill's bio | Prints |

Bill Irwin, photographer

I am a full time professional photographer based in Methven, middle of the South Island of New Zealand. My photography is about landscapes and people. Superb image quality is my style, using a low volume, highly crafted workflow. Read more about my photography in my bio...

Beautiful, professional photography

Landscapes

Photographing our wonderful South Island landscape is my main work. I look for art in the outdoors rather than just recording pretty scenes - and then take pride in crafting beautiful prints on fine art materials. Some of these images are also available for licensed use. See some beautiful landscapes

Art, about people

I am not a portrait photographer but love photographing people. That is, I don't do weddings, family groups etc but I love photographing an individual with the same approach as my landscapes: it's all about beautiful light on beautiful form. This creates portraits that are of a person but not necessarily about them. Confused? See how I see people here, then talk to me if this is what you want.

Photographic Commissions:

If you have a project that needs images that stand out from the crowd give me a

Visit our gallery

You are welcome to visit our home gallery any time, just phone first to make sure we are home. You can see some beautiful prints, with all the styles (on fine art paper, canvas, framed, matted, different sizes...). I can make a print in the exact size and style you prefer, usually within a week of ordering. In our gallery my partner of many talents Cheryl also has her paintings, sculpture and silver jewellery. Phone 03 302-9905.

Website — It's a given that we need websites. My dilemma has always been: what is its purpose? Is it a portfolio or a shop? I have yet to see a photography website that successfully combines the feel of luxurious, high-value prints with an online store. Once shopping baskets are involved, prints become commodities and people make buying decisions based on price.

The biggest challenge is how people see your images on their computer screens. I have a lovely 24-inch Eizo monitor that is properly calibrated, but viewing images on a screen still doesn't compare to physically holding a beautiful print. In the real world, people are looking at my website on uncalibrated, oversaturated, excessively bright laptop screens. They may think about spending $39.95 on an 8×10, but not several hundred dollars on larger prints. However, if they have previously seen my prints, they understand the quality and are happy to buy.

My experience is that a website should be simple, let the images provide the impact, and avoid loud colors or design elements. There does need to be enough of a story so people understand where you are coming from. The worst websites are too minimalist; you have to search to find how to navigate, and there is no

text. Keeping it fresh is important; it should be easy to swap new images in and out. I have found SlideShowPro to be an excellent content management system.

Some people believe the images should speak for themselves. I don't agree; I like to know what goes on in a photographer's mind—it helps add context and emotion to the image. People are buying not just an image, but a story, an experience. For this reason I like to write from a first-person point of view—I'm communicating directly with people who come to my website. I don't want it to feel cold and impersonal, or mysteriously vacant as many photographers seem to be.

Social Media — Social media is another way of enabling emotional connections with your audience. The downside is how much time it can soak up for a return that is hard to gauge. I tinker with Facebook, Twitter, Google+, and Instagram, as well as having a blog on my website. I am guilty of not being regular enough with updates in all of these forums, but I do enjoy the feedback they generate. I have a feeling that the audience here is not the one who actually buys prints; they are so used to an overload of free images on screen. But it all adds to presence and credibility.

Home Gallery — Two years ago we began a new house-building project. The aim was to have a home that also worked well as a studio and a home gallery. The main entrance is a large, high-ceilinged hallway of about 36×10 feet. It has a clever use of windows to give nice natural light with maximum wall space. My office (with printing equipment) is adjacent to the gallery and at the end of the

gallery is my photographic studio, which can function as extra gallery space. Cheryl, my wife, has her own art studio opposite my office, and the living area of the house is separate from the public working space.

It has proved to be a beautiful way to work. The commute is about 20 yards, and we have complete control over how our work is displayed. There is no overhead of staff to employ, building to rent, and so forth.

I make sure there is a full range of sizes, materials, and framing options on display so people can see all the possibilities. Once they settle on their favorite image then it's easy to guide them to a style they like in their price range, which I then custom print and deliver within a few days. Unlike a dealer gallery, there is no competing artwork.

People enjoy talking directly to me—the person who created, printed, finished, and delivered their print. I love talking to people about what my photography means to them. The personal connection adds so much more value on both sides.

The downside is that people need to know about the home gallery and make it a destination. Foot traffic is nonexistent. We advertise in local media as "open by appointment," though most people nearby know they can pop in to see what is new or talk to me about custom printing something. There is a steady trade in prints bought for gifts to others. To catch visitors passing through town, we have a large window display, effectively a billboard in the central town mall. There is a risk of people monopolizing my time by using a visit as free entertainment, but so far that hasn't been a problem. People are nicely surprised by what they find, and even if they don't buy today, it is a potential future sale or referral.

Conclusion – For the way I work, a home gallery is my ideal solution. My style is low volume, highly crafted. Sales depend mostly on people seeing physical prints to appreciate the quality. Being able to connect directly with the creator and printmaker adds so much value for the buyer; they receive a truly individualized service. The biggest challenge is to find the right mix of time spent out photographing versus time spent printing and marketing.

Rather than churning out products, I show buyers the possibilities and help them create their ideal solution. This is not something I can scale up to a massive business because it will always be limited by my time, but my days are full and happy. I value the direct connection with buyers and have learned to appreciate that local people love to buy local images.

Contact Information
Website: www.billirwinarts.com
Email: bill@billirwinarts.com

Skill Enhancement Exercises

What do you like in Bill's approach to marketing his work?
What do you not like in Bill's approach to marketing his work?

Make a list of what you see as being the strong and the weak points of Bill's marketing approach. Once that list is complete, decide about what you can use from this artist's approach and write answers to the following questions:

- ❯ What do you see as being useful for your own marketing approach?
- ❯ What do you see as not being useful for your own marketing approach?
- ❯ Is there anything missing from this artist's marketing approach? If yes, what is it?

Story 3
Bob Fields:
Gallery Representation Sales

Background

Bob Fields sells his fine art photography of the American Southwest in a brick-and-mortar gallery in Creede, Colorado. For Bob, selling photographs is a passion, not a financial necessity. His desire is to share his work with others and recoup some of the expenses involved in doing photography.

Selling your work through a brick-and-mortar gallery has serious advantages: you give your matted and framed photographs to the gallery owner, who takes care of displaying, marketing, and selling them. After the sale is complete, you receive a check minus the commission taken by the gallery. This commission can vary from 30 percent to 60 percent, depending on the gallery.

There are also disadvantages to selling in a gallery, the first one being that you only get a percentage of the retail price, while you would receive the full amount if you sell it yourself. However, because you do not need to spend money for display space, art show fees, booth equipment, advertising, and other expenses, this arrangement can be worth it.

To be successful selling through a gallery you must build a solid relationship with the owner and stay in regular contact. You must deliver work in a timely fashion and be present at the gallery for shows, openings, and other events. You also have to agree to specific conditions; for example, not to sell through another gallery in the same city or geographical area and not to charge a lower price for similar work sold on your website, at shows, in other galleries, or at other venues.

In Bob's Own Words

I was born in Dallas, Texas and grew up there. I learned photography from my father, who was an amateur photographer and owned a camera store in the 1940s. He sold the store, but it was only two blocks from our house; as a result,

Commodore Mine at First Light © Bob Fields ▸

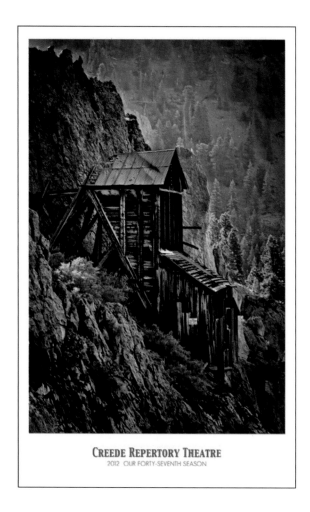

CREEDE REPERTORY THEATRE
2012 OUR FORTY-SEVENTH SEASON

I grew up surrounded by photography equipment and photographers. I went to high school at the Abbey School, run by Benedictine monks, in Cañon City, Colorado. Several of the monks were avid photographers and they had a large, extensive photo lab. During four years of high school I had the privilege of work-ing alone in my school's photo lab, using 35mm Leicas and Alpas as well as Crown Graphic 120 and large-format cameras, and processing my own black-and-white film and prints.

After college, a stint in the Navy and a career with AT&T did not afford much time for photography. After my retirement in December 2000, I immersed myself in photography once again. I focused on digital landscape photography, based on what I knew from my early days in the wet lab along with the new things I

learned from attending workshops and seminars, as well as from exploring the many online training venues.

I have always loved the contrasting landscapes, solitude, and stunning beauty of the greater Four Corners area of Colorado, New Mexico, Arizona, and Utah, where I concentrate my photography. I believe that we truly live in the golden age of photography, where artistic expression is no longer limited by technology. Today we can create images that would have been technically or financially out of reach, or even impossible, 10–20 years ago. Technology has afforded us the opportunity to produce beautiful pictures that heretofore were almost unimaginable.

There are many points between documentary reality and artistic impressionistic expression. Modern photography affords the photographer/artist great latitude to share his or her expression or vision of the world's beauty, contrast, balance, and diversity through the medium of light, color, tonality, and gesture. That is my goal. That is what I wish to create and share. I am inspired by Josef Sudek, Alain Briot, Ansel Adams, Edward Curtis, Edward Weston, Pierre-Auguste Renoir, and Rembrandt van Rijn. For me, the print is my ultimate objective—a beautiful image you can hold in your hands or display in your home or office. The photographer Vincent Versace said it best: "You are in service of the end, which is the print. The print is in service of your voice, which is what you want to say, which is why you took the picture in the first place."

We all dream of having our images displayed and sold in a prestigious gallery located in a fashionable city such as Telluride, Santa Fe, or Los Angeles—a noble goal, but unrealistic for most. First off, if you are lucky enough to be chosen for any gallery, you have to come to grips with the fact that you relinquish to the gallery owner almost total control of how your work is marketed and sold. That is a key point. So, unless you have a large following that will seek out your work, you are left to personally sell your work at the gallery's special openings and advertised events, hardly an environment where you are in charge.

Nevertheless, I sell a significant number of photographs in a small gallery in the town of Creede, a small silver mining town in southwest Colorado. It is not a high profile, fashionable city, but its uniqueness offers some very attractive opportunities for the artist. It has a nationally recognized repertory theatre that brings money and thousands of patrons to the area every summer, along with

hundreds of summer residents and a steady stream of tourists. There are several thriving art galleries and gift stores that cover a broad market, from inexpensive local art gifts and trinkets to numerous works of fine art that sell locally and internationally for thousands of dollars. My wife and I have been vacationing in the area for over 35 years, so we have many friends who live, work, and likewise vacation in the area; a basis for developing a following. The gallery owner and I have a strong personal relationship that goes back many years, making it easier to negotiate marketing and sales issues. Since I am the only photographer in her gallery, it is an advantage that limits my competition. She is well connected in the community, promotes all her artists with equal enthusiasm, and the community responds.

One of my images was recently chosen as the limited edition poster for the Creede Repertory Theatre 2012 season. The theatre will also be selling note cards of my images. I am being modestly compensated, since they operate as a non-profit organization, but the name recognition is significant! In their 46 years, they have only featured one other photographer. I am planning to sell signed and framed prints of the poster image exclusively through the gallery at a significantly higher price point than the posters because they are originals printed by me. They will not cannibalize sales at the theatre since the originals appeal to high-end buyers who collect original art.

When I first had a showing at the gallery I was displaying photographs of slot canyons and desert landscapes. They received many favorable comments, but no sales. Well, actually one image I took in Brugge, Belgium of a draft horse sold to a young girl who loves horses. Those one-off sales can be charmingly seductive

to an artist, but don't let them cloud your marketing. Soon, the gallery owner convinced me to concentrate on the Creede and southwest Colorado areas—the old abandoned mines, the local landscapes of mountains and streams. As soon as I did, my sales took off. People don't come to the mountains for desert pictures. In other words, know your buyer. The gallery is featured in local brochures and magazines, often with the names of featured artists. It also has a website that features artist images and is linked from the Creede city website.

This gallery owner also has a thriving framing business in addition to selling fine art, something to look for when you are scouting for a gallery. My advice is to find a small, established fine art gallery that is not beset with the demands and politics of a large fashionable gallery. Steady, profitable cash flow is critical for a small business owner as well as the artists they represent. If the biggest and most beautiful gallery in town is not making the rent and utility payments, they soon will be out of business, and the artists will be looking for a new gallery and maybe their last check due from sales of their work! Check out the gallery owner's reputation and don't be afraid to ask them and other nearby businesses how well they are doing. You can present your work to the owners of big prestigious galleries, who may give you that break you are looking for, but you may waste a lot of valuable time hoping for that discovery. You can't win the lottery if you don't buy a ticket, but you have to consider the odds. If you can establish yourself in a smaller, more focused environment, as I have described here, you can build a reputation and following that can successfully grow your revenues and expand your brand and name recognition with a reasonable amount of control.

Contact Information
Website: www.frameshopcreede.com
Email: bobfields@bobfields.net

Skill Enhancement Exercises

What do you like in Bob's approach to marketing his work?
What do you not like in Bob's approach to marketing his work?

Make a list of what you see as being the strong and the weak points of Bob's marketing approach. Once that list is complete, decide what you can use from this artist's approach and write answers to the following questions:

❯ What do you see as being useful for your own marketing approach?
❯ What do you see as not being useful for your own marketing approach?
❯ Is there anything missing from this artist's marketing approach? If yes, what is it?

Story 4

Christophe Cassegrain:
Sales on Personal Website

Background

Christophe Cassegrain sells his large-format fine art photographs of the American Southwest internationally on his website and locally through art shows near Paris, France. These two venues work together toward the same goal. The website presents Chris's work to collectors worldwide and allows them to make purchases online 24/7. The art shows offer people and collectors the opportunity to see Chris's work in person.

Selling fine art on the web offers many advantages. First, it drastically reduces operational costs because the cost of running a website is very low compared to the cost of operating a physical gallery. Second, it allows the artist to get 100 percent of the selling price instead of getting only a percentage when sold through an independent gallery. Third, it allows the artist to change the catalog, prices, description, artist statement, and other marketing materials at any time with a minimum amount of difficulty and delay.

However, selling fine art photography (or another medium) on the web offers challenges as well. The main challenge is that collectors cannot see the work in person. This greatly reduces the emotional impact of the work. Both large and small pieces look the same on the web because they are reduced to web page or monitor size. In addition, the quality of a fine art print is greatly reduced when shown on a web page.

Seeing a fine art print in person is a completely different experience than seeing a JPEG version of it on a monitor that may or may not be calibrated. All this means that selling fine art on the Internet is challenging, especially when it comes to large or expensive pieces.

Paria Soul © Christophe Cassegrain ▸

Showing original work at shows in addition to the web, the way Chris does, is an effective solution. Chris offers a solid money-back guarantee to web purchasers, which goes a long way toward alleviating the hesitations collectors have when ordering fine art sight unseen. Another approach used by Chris to offset the challenges offered by the Internet is to have his work listed in auction catalogs (see the *Drouot Cotation* catalog photographs above). By providing auction sales records of his work, Chris offers a reliable way of assessing the value of his work.

In Christophe's Own Words

Photography and travel have always been my passions. After five years of study in marketing and management, I spent six years working as a sales representative and traveled all over France. In 1995, I left my job in order to dedicate all my time to photography, working as a fine art photographer.

During my extensive travels on the North American continent, I built up an image bank of tens of thousands of photographs, and so it was only natural that I began my activity as a photographer by distributing these images to the specialized travel agencies across the United States and Canada.

In 1996, in collaboration with a friend who is also a photographer, I created a company designed to distribute our combined collection of images—some sixty thousand slides. Our approach was quite simple: to propose a comprehensive and adapted bank of images for distribution to travel agencies. By using this strategy, we were able to cover most of the tour operators' needs—in certain years as much as 80 percent—for images used as covers, inside pages, and promotional posters.

This wide-scale distribution was quickly noticed by publicity agents who were looking for typical American scenes for their publicity campaigns. Over a period

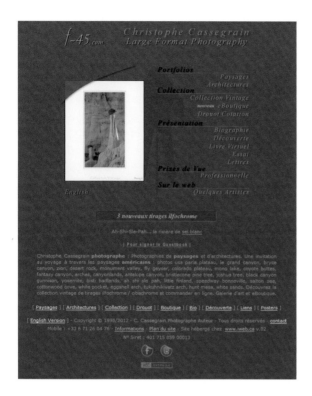

of nearly eight years, the Léo Burnett agency used images from our bank for their campaigns for the internationally known Philip Morris cigarette company. This image bank clearly connected with a wide market in the sector of illustrations for magazines, the press, tour operators, and so forth. But today, with the arrival of digital technology and the increasingly rapid distribution of images, this image bank, which was composed of 95 percent slides, is no longer exploited at its true value. We are currently constructing a new bank of digital images.

In parallel with this bank of photographs from the United States, and following a series of trips to Argentina in the 1990s, I registered my images of South America with the agency PIX (since bought by Getty Images), which constituted an interesting source of income at that time.

In 1997, I realized that the Internet could be an extraordinary means of presenting photographic work, so I created my first website. I displayed several images and some stories concerning my different journeys, rather like a window opening onto the world. The website quickly turned into a portfolio. The primary goal of this portfolio was to present a collection of about 30 Cibachrome prints realized by the printer Roland Dufau, set to coincide with my first collective exhibition at the

Espace Nesle in Paris. During the course of this exhibition, three of the four Cibachrome prints were sold.

Today, my website has two approaches: The first concerns the sale of a limited edition of fine art photographic prints of landscapes on Cibachrome paper. Each shot is realized with a 4×5-inch camera and represents the visions I saw in the deserts, canyons, and landscapes of the American West. Taking into account the cost of a Cibachrome print and the limited number of enlargements, these sales are addressed mainly to a limited and knowledgeable public. In parallel with this fine art portfolio, I also have an online store where customers can order the Cibachrome prints via the Internet and pay through PayPal. This store only represents a small percentage of sales because it is technically difficult, on a 72 dpi screen, to suggest the quality of detail and the subtlety of color obtained with Cibachrome to anyone who wants to buy a print online! Nevertheless, it is an interesting option since it remains open 24/7 all over the world.

My website's second approach enables the presentation of all my photographic work in a more general manner. As a result, I have been contacted by companies such as Egim (Italy), Les Editions Lavigne (France), and Nouvelles Images (France). These contacts led to the creation of a series of 20 posters for Egim and a series of calendars for Lavigne. This approach is made possible by an efficient optimization in web search engines such as Google. In this way, a search for "photographe paysage" or "photography landscape art" or "photo paysage États-Unis" makes it easy to find me. One of the major advantages of a website

for presenting photographic work is that it can be updated easily and at low cost. A multilingual site also facilitates contact with a wider public.

Presenting images in exhibitions or art fairs is often the ultimate goal of photographers who wish to publicize their artistic work. France—and more generally, Europe—has a long history with photography (the seventh art, as it is called in France) and a large number of photographic exhibitions or art fairs are held every year. But in contrast to the United States, for example, landscape photography—or straight photography—is poorly represented in France and does not elicit the same interest as in the United States.

I discovered the 4×5-inch format camera about 15 years ago, and it was a revelation for me. The particular manner of capturing the landscape in this format, and the encounter with the printer Roland Dufau, inspired me to pursue displaying my images in photographic exhibitions and art shows.

Since 1995, I have presented my work in galleries and art shows about 15 times. Each print is a unique piece that is numbered and signed. The price of the prints varies from 250 euros (about $330 at time of writing) for the smaller formats to about 1,400 euros (about $1,850 at time of writing) for the large formats. A piece printed by Roland Dufau brings with it a guarantee of quality and expertise in the art of printing on Cibachrome paper.

The often-limited space in exhibitions or art fairs does not allow me to present the totality of my Cibachrome prints. That's why the website is an important asset for presenting information to potential buyers. It enables me to present a wider choice of prints and also to emphasize the quality of the enlargements shown at the exhibition.

The demand for beautiful Cibachrome prints is still in full flood! In fact, at the end of 2011, the Ilford Company suspended the production of this paper, and, as of today, there remains only about a two-year stock. This has resulted in the rapid rise in the demand for, and the price of, Cibachrome prints.

As I pointed out earlier, the website, exhibitions, and art fairs are very fruitful sources for contacts. Art and antiquities expert Christian Sorriano was commissioned by the French government to create an art rating and pricing guide that could be used to estimate the value of works of art. In 2001, Sorriano created the first *Dictionnaire des Artistes Cotés*, which provided estimated prices for photographs, paintings, and sculptures. The *Dictionnaire* has been published annually since then and is a respected resource for gallery owners, experts, collectors, and for those who are interested in the art market.

Having seen my photographs for sale at exhibitions and art fairs, Sorriano contacted me and proposed to include three of my fine art photographs in the *Dictionnaire*.

To sell art you must be known, and in order to become known, you must sell. Having my photographs featured in the *Dictionnaire* shows that my work has reached a significant level of recognition, and it gives buyers and collectors a reliable way to establish the investment value of my work. It also demonstrates the value of limited edition Cibachrome prints.

In 1997 and 1998, I submitted six 30×40 cm prints, followed by two 30×40 cm prints, to the Bibliothèque Nationale de France (BNF). They were accepted and can be found in the archives for the landscapes of America under the references MA.97.00319 and MA.98.00049.

In the sector of fine art photography, talking to the media also helps to increase an appreciation of the work. Several websites and print magazines have published interviews about my approach to photographing landscapes. These interviews can be found in magazines such as *PhotArgus, Photo Plus, Initiation à la Photo Numérique* (édition Ficom), *Oracom* (May 2012), and also on the websites Pose partage (pix-populi.fr), Fujifilm (fujifilm.fr), Éditions Luigi Castelli (edition-sluigicastelli.com), and more.

Digital technology has revolutionized the world of images. Today, images are no longer a means of expression, but a product for general consumption. By the rapidity of its treatment and distribution, the photographic image known as *straight photography* seems to me to be less and less valued as a work of art, but rather as a product that is now judged in terms of productivity and profitability. In this context, and from the point of view of the artistic photography of landscapes as I considered it at the beginning of my activity, I think it will become increasingly

difficult for those who undertake this path to make a place for themselves, at least in the European market.

Producing works of quality, and especially works of passion, are important criteria if you want to earn a living from your work as a photographer.

Contact Information
Website: www.f-45.com
Email: service@f-45.com

Skill Enhancement Exercises

What do you like in Chris's approach to marketing his work?
What do you not like in Chris's approach to marketing his work?

Make a list of what you see as being the strong and the weak points of Chris's marketing approach. Once that list is complete, make decisions about what you can use from this artist's approach and write a list:

- ● What do you see as being useful for your own marketing approach?
- ● What do you see as not being useful for your own marketing approach?
- ● Is there anything missing from this artist's marketing approach? If yes, what is it?

Story 5

Carl Johnson: Fine Art Stock Image and Print Sales on Personal Website, and Custom Assignments

Background

Carl Johnson sells his fine art photographs of Alaskan landscapes as stock images on his website. Carl also creates photographs for commercial clients through customized assignments.

One of the advantages of selling stock photographs is that the same photograph can be sold to multiple clients. Another advantage is that you do not need to make prints of the images. Instead, you provide a digital file to the client, who then uses it in digital or print media. Selling stock images through a website carries low costs compared to having to print a physical catalog. Finally, updating your stock listings on your website can also be done at a low cost compared to having to reprint a new catalog each time you add images to your collection.

However, there are disadvantages as well. For one, not all clients want stock photographs. Some want photographs created just for them. Carl addresses this issue by offering custom photography assignment services. However, your shooting fee must be high enough to justify the time required to complete these assignments. Otherwise, doing these will eat into the time you have available to run your business. Another disadvantage is the huge price drop that stock photography has experienced as a result of digital stock offerings. Before the Internet, stock photography offered a solid income opportunity. Now that anyone with a website can offer stock photography for sale, what used to bring a good income now brings back pennies on the dollar.

Certainly, offering quality fine art stock photography the way Carl does improves the odds of making a good living doing this. However, regardless of quality, selling stock photographs is a numbers game: you have to constantly generate a

very large number of sales to earn a sufficient income. Carl compensates for this challenging situation by also selling fine art prints, an approach that I encourage.

In Carl's Own Words

I started my photography business 10 years ago, after dabbling for a while as a serious amateur. I began with print and note card sales in local shops and fairs, and eventually expanded to include stock sales. My current focus is on documenting wild places, through capturing dynamic landscapes, amazing wildlife, diverse plant life, and people in the landscape. An increasing percentage of my annual revenue comes through licensing images for commercial and editorial use.

The starting point for generating revenue through stock photography is to take photographs that are sellable as stock. Fine art landscape or macro images generally do not translate well to stock images. The best way to see what makes good stock photographs is to visit a stock agency website. Images with people

and young animals, by and large, sell more than anything, along with dynamic images of well-known landscapes. Capture images that strongly convey mood or emotion, are stand-alone storytellers, and have dramatic color. Always have model releases on hand to execute in the field in order to maximize the potential sales for any image with people.

There are two ways that I make sales from stock images. First, I am represented by a stock agency—Alaska Stock Photography (alaskastock.com), an Anchorage-based firm that specializes in images of Alaska and Canada. I chose this firm because of their reputation for high quality and their pervasiveness in the marketplace. Whether on calendars, note cards, or magazines, most stock images of Alaska come from Alaska Stock.

To get started with stock agency representation, look locally. Examine products and publications you respect and see who produced the stock images that are used. The advantage of representation by a stock agency is they do the marketing and they routinely conduct global searches to ensure that all the images in their collection are not used without proper licensing. If there is a copyright

infringement, they take legal steps to protect the photographer's image usage.

My second approach to selling stock photography is through direct marketing. If you have a local or regional niche in stock images, then it is worth your while to reach out locally as part of your marketing. First and foremost, develop a client database. Over the years, I have given many presentations at local business meetings, photo clubs, museums, and national parks. Each time, I have a sign-up sheet for my newsletter with a free gift for those who join. I also joined Business Networking International (bni.com), which provides word-of-mouth referral networking in numerous local chapters. Since stock sales are made almost exclusively to businesses, I target business clients through BNI by touting the advantages of having attractive stock photographs for websites, calendars, brochures, rack cards, and other marketing materials. Participating in BNI develops both direct client sales and contributes to the ongoing development of a client database.

I use my client database to send out a monthly electronic newsletter through the marketing/mail service Constant Contact (constantcontact. com). I include special offers, highlight recent images that have been added to my online library, and announce upcoming trips. Often, I find that if a client knows where I am going, there may be a particular image they are

looking for that I can capture during that planned trip. I have found that electronic and personal direct marketing (through meetings) is far more productive than mailing rack cards and brochures or placing print ads.

When making your own direct stock sales, you need to have a user-friendly website that provides for direct downloads of high-resolution images in connection with a licensing sale. You also need a pricing matrix that takes into account the various elements that determine the price of a stock sale: use, geographic distribution, image size, and circulation, to name a few. I use PhotoShelter (photoshelter.com) for the underlying coding to set up sales—both print and stock—and then overlay a custom graphic design over the PhotoShelter website. I can host up to 1 terabyte of high-resolution photographs, all of which are keyword searchable (good for search engine optimization, or SEO) and available for immediate download when a client makes a rights-managed purchase.

Finally, it is important to incorporate your marketing objectives into social media. I cross post everything between Constant Contact, Facebook, Twitter, and my blog. I provide special offers to my Constant Contact subscribers as well as my Facebook fans—very few of the contacts between those two databases overlap. I also use Facebook and my blog to tell the story behind particular images, to help my fans and clients make a connection with the images. I find this generates interest and adds value. And whenever I post anything on my blog, on Facebook, or on Constant Contact, it also goes out via Twitter.

Contact Information
Website: www.carljohnsonphoto.com
Email: carl@carljohnsonphoto.com

Skill Enhancement Exercises

What do you like in Carl's approach to marketing his work?
What do you not like in Carl's approach to marketing his work?

Make a list of what you see as being the strong and the weak points of Carl's marketing approach. Once that list is complete, decide what you can use from this artist's approach and write answers to the following questions:

- ❯ What do you see as being useful for your own marketing approach?
- ❯ What do you see as not being useful for your own marketing approach?
- ❯ Is there anything missing from this artist's marketing approach? If yes, what is it?

Story 6

Ruth C. Taylor:
Selling Retail at Fine Art Shows

Background

Ruth C. Taylor sells her fine art photographs at art shows. Her images are of landscape and nature scenes of Pennsylvania and New Jersey, as well as the surrounding Northeastern and Mid-Atlantic states. Selling fine art prints at art shows is an effective way of making a living as a photographer.

There are many advantages to selling your fine art prints at art shows. Shows offer an opportunity to meet collectors in person. Having the artist present at a show is a major selling point because collectors love to interact with the artist, have a photo taken with the artist, and have their purchase personally dedicated by the artist. Shows also offer the opportunity to identify which pieces are popular. People who "vote with their money" provide an accurate way of knowing whether a piece is popular or not. In addition, selling at art shows provides the ideal opportunity to practice salesmanship skills in a live setting, something that is much more challenging to accomplish over email or over the phone.

However, art shows also have disadvantages, such as the long hours required to travel to a show, set up your booth, and conduct business from early in the morning to late in the evening. It is not uncommon for shows to open at 7 a.m. and to end at 8 or 10 p.m. This means long hours spent in your booth answering questions and trying to close sales. You have to enjoy interacting with people to be successful at shows, otherwise you will get tired of having to answer questions. Since you cannot reasonably expect to close 100 percent of the sales, disappointment and frustration can also set in unless you know how to compensate for that.

The solution to doing shows successfully is to be prepared and know what to expect. Teaching you how to do this is the focus of my previous book, *Marketing Fine Art Photography*.

Autumn Stroll Along the Canal © Ruth C. Taylor ▸

In Ruth's Own Words

I began photography in 2003–2004. But I became serious about my newfound passion after receiving requests from businesses to license my images, and when people who saw my work online said they wanted to purchase it. My husband, Steve, set up my website so I could start selling my work online.

In 2005 I was asked to show and sell my images of a local garden at their annual Azalea Festival, and to my surprise, my work was well received by the attendees. In 2007, someone saw my work online and asked if I could participate in another local festival. To do this I needed an art display and a tent, which were things I did not have. Luckily, during the previous year Steve had been researching how to display art and he soon purchased a tent and walls for me from the Flourish Company (flourish.com). That year I did my first four outdoor art festival shows.

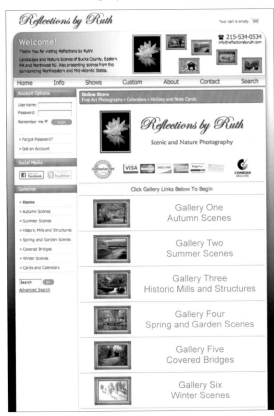

What Does and Doesn't Work for Marketing My Photography

I market myself on my Facebook page (facebook.com/reflectionsbyruthphotography). I am also lucky because the local visitor center that licenses my photography also promotes my work on their Facebook page and directs viewers to my website.

Getting accepted in as many local festivals as I can handle during the season (since not all the same people attend each area's events) helps my marketing strategy. At each event I notice how many people are seeing my work for the first

time and how many already seem to know of me and follow my work, or are repeat customers. It helps me make informed decisions for future festivals.

 Being found via Google has been the second best way potential clients have found me other than at art festivals. I have flyers available at all my art festivals. On the front of these flyers is a description of my work: on the back is a list of all my current-year festivals. This has led to people following me while they make a purchasing decision.

Recommendations for Photographers Who Are Starting to Sell Their Work

I try to shoot scenes that the local residents will recognize. I also try to find the best light and to be creative in my compositions, so they are different from what I have seen others portray.

Should you decide to sell your work at outdoor festivals, you need to interact with those stopping by to view your work. The more shows you do, the more you will begin to recognize when and when not to approach people. Some visitors enjoy your interaction while others require warming up to. I pay attention to which images people are interested in, and if I can, I tell them a little story about the image. Everyone seems to enjoy that, and it sometimes leads to a sale.

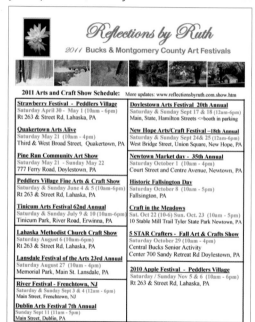

Contact Information

Website: www.reflectionsbyruth.com
Email: ruth@reflectionsbyruth.com

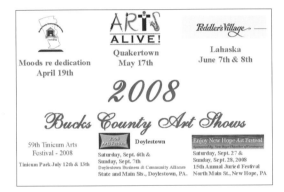

Skill Enhancement Exercises

What do you like in Ruth's approach to marketing her work?
What do you not like in Ruth's approach to marketing her work?

Make a list of what you see as being the strong and the weak points of Ruth's marketing approach. Once that list is complete, decide what you can use from this artist's approach and write answers to the following questions:

- ❯ What do you see as being useful for your own marketing approach?
- ❯ What do you see as not being useful for your own marketing approach?
- ❯ Is there anything missing from this artist's marketing approach? If yes, what is it?

Story 7
Carol Boltz Mellema:
Fine Art Photography Portraits

Background

Carol Boltz Mellema creates fine art photographic por-
traits for private clients in her home studio in Oswego,
Illinois.

There is a vast difference between marketing land-
scape images and portraits, the main difference being
that while a fine art landscape photograph can be sold
to multiple collectors, fine art portrait photographs
can only be sold to the sitter or to his or her family.

The fact that each portrait is created for a single person or family has import-
ant implications for the photographer. While fine art landscape photographers
can continue selling their work even if they no longer photograph, a portrait pho-
tographer must continue to shoot in order to generate an income. Furthermore,
while the original owner can resell fine art landscapes, there is no secondary
market for portrait photographs.

However, when created as fine art pieces with an emphasis on quality rather
than quantity, portrait photographs do qualify as fine art. Furthermore, they rep-
resent a reliable and significant source of income. Indeed, portrait photography
is one of the most important sources of income for photographers, together with
wedding photography. Therefore, fine art photography portraits are something
to consider doing if you have the skills and the desire to do so. For these reasons I
decided it was important to feature a portrait photographer in this book.

In addition to the requisite skills as a photographer, to do portrait photogra-
phy successfully you must have strong people skills. This means you must enjoy
working with people and you need to have the necessary patience. It helps if you
can have an assistant working with you, someone who is able to take care of the
multitude of little things that come up during a shoot.

Having the proper marketing skills is also a requirement. Because the
photographs can only be sold to the sitter and his or her immediate family,
each sale must be significant. Because creating fine art portrait photographs is
time-consuming, each session needs to generate enough money to make this
business endeavor profitable.

In Carol's Own Words

Nine years ago I started my business as a professional portrait photographer when my youngest son was beginning kindergarten. At that time my husband and I owned a business, primarily run by my husband, where I worked a couple of days a week. I really wanted something to call my own, though, so I went back to my love of many years: photography. At the time, there was never any question that I would become a portrait photographer. My many years in client-centered fields made it an easy choice. I wanted to be in a career where I could interact with my clients on a regular basis. And interact I do! I have the privilege and honor of watching many of my clients go from newly pregnant, to parents, to parents again, all the while falling in love with each new addition to their family as if it were my own. I always tell my clients, "I have the perfect job! I get to play with your kids, and then send them home with you." It doesn't get any better than that!

Because my approach to my work is so client-centered, my selling style is client-centered as well. My venue consists of a small, intimate, and comfortable sales room located in my home studio. This room is about 10'×10' and is furnished with a comfortable sofa, a chair, a small desk for me, and a large-screen television on which my clients can view their images. I use a program called ProSelect to present my photographs to my clients.

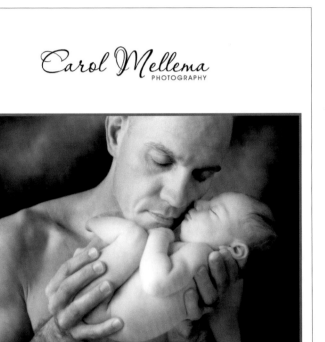

ENTER SITE

The room is very homey, as is the rest of my studio, which is located in an old house that was built in 1926. On my walls are lots of sample photographs, so that clients can visualize what they will be purchasing. I not only sell photographs, but I also sell collage pieces (very popular), albums (both large and small), announcement cards, handbags, some jewelry, DVD slide shows set to music, and other smaller items. My studio can be described as a boutique studio, which I define as "a small exclusive business, offering customized service." Everything, from the initial planning meeting (usually via telephone) to the final delivery of the photographs is done on an individualized and custom basis.

My approach to marketing is multi-faceted and dependent on whom I am marketing to. For example, when I am marketing to high school seniors, I market to them mainly through Facebook. After all, this is where they hang out! When marketing to expectant mothers and new parents, I find my best venue to be email ad campaigns. I also have a couple of displays of my work: one at our local hospital's labor and delivery wing (located in a high-end town), and one at a local pediatrician's office (in the same town). While I have found that clients don't

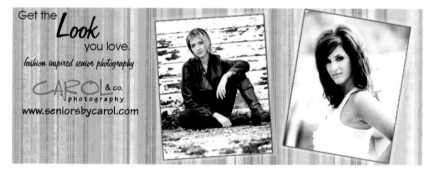

come to me just because they saw my displays, it does lend me credibility and gives me a certain amount of bragging rights with my clients. By far, though, my best form of advertising is word of mouth. I have programs in place so that when a client refers a friend, that client is rewarded on her next visit to my studio with complimentary products.

In addition to these marketing approaches, my website is a large part of my marketing presence. Through the years, I worked very hard on my search engine optimization, and many of my clients (especially high school seniors) tell me they found me through a Google search. If you search on Google for the words "senior photography Oswego," I come up on the first results page. I have

two separate websites—one geared toward children, family, and maternity and the other geared exclusively toward high school seniors. This second website is edgier and funkier. I make sure to put only my very best images in the galleries on my websites. I'd rather display 10 knock 'em dead images than 100 so-so ones.

If I could give any advice to new photographers just starting out, it would be this: Respect yourself and your work enough to charge appropriately for it. Do not be afraid to charge according to what you are worth. Take the time to really figure out your costs of doing business, plus what *you* want to be paid, and then set your prices

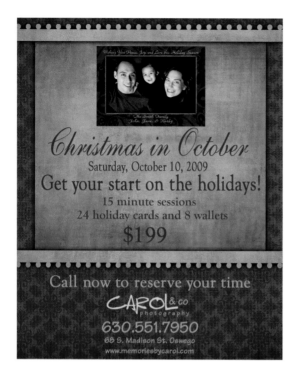

based on those figures, *not* on what the photographer down the street is charging. But most of all, write a well-thought-out business plan! Include a marketing plan too, with your marketing calendar and budget all laid out for the first year and beyond. And don't be afraid to ask another photographer for help. I had several local photographers come to me seeking advice, and we became fast friends. It's nice to have a like-minded individual in my area that I can count on in a pinch if need be. Better yet, join the Professional Photographers of America (PPA) affiliate in your area, where you can hang out with folks who love photography as much as you do, and you will learn a lot along the way. Our PPA affiliate holds monthly classes where one can learn shooting techniques, marketing, or workflow tips, all for a great price.

Contact Information
Website: www.memoriesbycarol.com
Email: contactcarolco@gmail.com

Skill Enhancement Exercises

What do you like in Carol's approach to marketing her work?
What do you not like in Carol's approach to marketing her work?

Make a list of what you see as being the strong and the weak points of Carol's marketing approach. Once that list is complete, decide what you can use from this artist's approach and write answers to the following questions:

❯ What do you see as being useful for your own marketing approach?
❯ What do you see as not being useful for your own marketing approach?
❯ Is there anything missing from this artist's marketing approach? If yes, what is it?

Story 8

J.R. Lancaster: Sales in Personal Brick-and-Mortar Gallery

Background

J.R. Lancaster sells his fine art photo-graphs that focus on the American Southwest through his personal brick-and-mortar gallery in Bluff, Utah. In addi-tion to his photography, J.R. also creates sculptures, paintings, and mixed media pieces, which are also sold in his gallery.

To me J.R. is the quintessential artist/ photographer. His approach is centered on his vision with little concern for what mainstream America might want. This approach offers significant challenges because it focuses on the artist's vision rather than on current trends and fashions.

On the positive side, J.R.'s work offers a welcome reprieve from mainstream art offerings and instead, J.R.'s images are about his vision and inspiration. They are about what drives him, not about what drives people. His approach is what art should be about: challenging the status quo and offering something we have not seen before. This certainly appeals to collectors looking for uncommon and unexpected art. In the end, it is J.R.'s talent that brings him success. Over the years, this approach has earned him a strong following.

On the challenging side, collectors looking for what may be called *fringe* or *cutting edge* art are in small numbers. Therefore, J.R.'s prices need to be high in order to compensate for his relatively low number of sales.

The fact that J.R. has been in business for many years means that he has been able to navigate the choppy waters of visionary art successfully. However, doing so requires the ability to maintain a relatively inexpensive lifestyle in order to make ends meet. It also requires constant marketing and promotional work.

Having his own gallery works well for J.R. because it gives him complete control over how his work is displayed and sold. In addition to selling in his own gallery, J.R. successfully sells his work through outside gallery representation.

Monarch Cave Ceiling © J.R. Lancaster ▸

Guardians of the San Juan JR Lancaster

Lancaster Gallery

Fine Art Photography

✳

Contemporary and Vintage images of the Southwest

Limited edition prints, Portfolios, Handmade Books, Outdoor
Workshops, Custom Printing and Consultation Services.

Twenty six year exhibition history, Corporate, Museum,
University and International Private Collections.

Archival Black and White, Color, Polaroid Transfers, Digital
Iris, Multimedia Collages and Alternative Processes.
Contact prints to 32"x40" enlargements. Mounted on Museum
Rag Board. Framing available.

Landscapes, Abstracts, Still Life, Conceptual, Historical
Architecture, Enviromental Portraiture, Rock Art and
Commission work.

LANCASTER GALLERY
Hwy. 191 West P. O. Box 314 Bluff, Utah 84512 (435) 672-2307

Cover Photograph: *Guardians of the San Juan / Multi toned*
Silver Print, Copyright: All Rights Reserved. JR LANCASTER

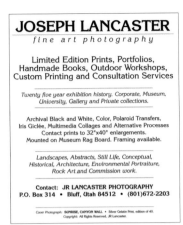

JOSEPH LANCASTER
fine art photography

Limited Edition Prints, Portfolios,
Handmade Books, Outdoor Workshops,
Custom Printing and Consultation Services

*Twenty five year exhibition history. Corporate, Museum,
University, Gallery and Private collections.*

Archival Black and White, Color, Polaroid Transfers,
Iris Giclée, Multimedia Collages and Alternative Processes
Contact prints to 32"x40" enlargements.
Mounted on Museum Rag Board. Framing available.

*Landscapes, Abstracts, Still Life, Conceptual,
Historical, Architecture, Environmental Portraiture,
Rock Art and Commission work.*

Contact: JR LANCASTER PHOTOGRAPHY
P.O. Box 314 • Bluff, Utah 84512 • (801)672-2203

*Cover Photograph: SUNRISE, CANYON WALL • Silver Gelatin Print, edition of 40.
Copyright. All Rights Reserved, JR Lancaster.*

In J.R.'s Own Words

I started out in photography around 1972 after seeing an Ansel Adams book at the Dallas/Fort Worth Airport. The black-and-white image of Half Dome stopped me in my tracks. It was one of those *eureka* moments. I can still recall the sublime beauty and power of that image. I had never seen a photograph so expressive or so finely executed. That was the initial spark that started me on this journey that still continues.

I began with 35mm cameras and eventually moved to large format, following the Ansel Adams school with its technical labyrinth called the Zone System. I attended one of the last workshops (in Yosemite) that Ansel taught himself and was fortunate to stay long enough to watch him work in the darkroom. From that point on, my study of photography increased to the point of obsession.

In 1983 I worked with Paul Caponigro Sr. assisting with the printing of two book projects and a major retrospective for the George Eastman House. Both Paul and Ansel worked in black-and-white traditional processes but possessed completely different views of the natural scene and how it should be interpreted. Ansel taught me how to render a physical scene in chiaroscuro. Paul taught me how to render the emotional quality of the landscape in gradations of silver.

Workshops play a vital role in stimulating creativity of a beginning or professional photographer. You not only learn from the instructors but you meet people who you will connect with (possibly) for the rest of your life. The sharing of ideas, information (including marketing tips), and scenic locations is invaluable.

Making yourself available for an apprenticeship is another proven method to develop your photographic acumen and skills. If you keep pushing, you can open

any door regardless of the name attached. A great artist will never turn his or her back on the ones who are following. They all started at the bottom.

One thing that I learned early on was that criticism can be your best ally. I worked with Caponigro for almost three weeks before I got the courage to show him my photographs. He flipped through the prints rather hastily, placed them back on the table and said, "A mere germ of an idea." At that time I was devastated and soon plotted my revenge to salvage my ego. I thought, "I'll show him what a mere germ of an idea is." But that is the wrong attitude. I can now blame my shallowness on youth. Later, the genius of those words finally dawned on me. It has stuck with me for over three decades and I made sure that the mere germ of an idea became a super virus.

When I first began to take photography seriously, I mounted an ambitious campaign to exhibit my work anywhere that had wall space—from public libraries, small galleries, outdoor art festivals, to home shows. Eventually I quit a successful career as a chemical engineer and took the plunge into photography. Let's just say this approach is not made for the individual who needs security, but if the passion for something burns to that degree then there is a only one way to satisfy this: hold your nose and dive in. Perhaps it's not as deep as you think. You will never know what you are capable of if you don't take risks. No breakthrough ever came from the comfort zone.

I expanded my photo horizons into magazine work, weddings, show horses, portraits, stock agency, fine art prints, and competitions (and all of this was in the archaic film and darkroom days). I always kept an eye for spaces to show and eventually had my work hanging in an exhibition with Ansel Adams and Edward Weston, but I was still struggling to pay the bills. Marketing was not my strong point but is a necessary part of the business if one desires to make a living with a camera. Otherwise you would be better off with that accounting job and keep photography in the amateur status, which means *out of love*—a most noble place to be. Some of the most beautiful photographs I have seen were made by amateurs. Although they were weak in certain technical areas, they made an image of beauty and meaning that stood on its own. That in itself is a form of success. And I have known professionals from the old school who went into digital and their images suffered from their unwillingness to embrace the new science of photography. The bottom line is how much time you are willing to dedicate to fieldwork, the computer, and marketing, in addition to time with your personal and family life. Time management is a crucial issue for any photographer.

I developed an interest in prehistoric cultures during my time with Caponigro and started journeying to Central America to photograph Mayan architecture. I was lugging around 90 pounds of gear through the jungle with a smile on my

face, even though I made some catastrophic errors. I had finally achieved some of the goals that I wanted. I think it is very important that photographers take a serious look at what they want from photography, where they want to go, what they are passionate about, and how they are going to make a living doing it. Usually the latter involves some very creative marketing. People who live in Boston do not have the same taste as people in Chicago, so research and market analysis is vital. You can be the greatest image maker on the planet, but if you do not have a market then the thrill will soon be gone. But use wisdom with who you emulate. If it is Ansel Adams, then prepare for a lot of work. If it is Vincent van Gogh, then prepare to suffer (and hold on to your ear). You can learn from either school, but you must take those bits of knowledge, what works for you and what doesn't. Each carries equal weight. You can then incorporate those gems into your method of operation. Resignation is for losers. There is not a successful artist out there who gives up when the going gets tough. I know that is a trite saying, but it has more value to an artist than being on the cover of *Art News* magazine. As the late Imogen Cunningham said, "Never give up!"

Photography is a medium that can open many doors. It is infinite in its capacity for expression and in what one can learn from the process. And if you are serious, that process must be integrated into your life. It is a very competitive business, and one must find their niche and pursue it with enthusiasm and determination. It also helps to find quiet time to reflect on your progress and goals. If something doesn't work, then go to something else. At least you have learned what didn't work. All great creative people will agree that if you do not push yourself to the point of making mistakes then you are not working hard enough. Take a look at the greats, say, Ansel (again), who after fifty-some-odd years of making images, founding schools, writing dozens of books, and mounting vast exhibitions, is basically known for a few dozen images. He once told me that if you can make one masterpiece a year then you should be proud of that. But if you are a journalist making a living from magazine work, then that credo does not apply.

You have to find your own path because the line of photographers wanting to get into galleries stretches beyond the horizon. And in today's high-end art world, more and more painters are using photography in their work. So the competition is at an all-time high. You will have to do something unique and finely tuned. Never sign or show any work that is not worthy of gallery walls. And the more exhibitions you can see, the more you will stay on the path to success.

Many people send portfolios by email, and a percentage of galleries say they prefer this method. But they are just being polite. The big galleries usually represent more people than they can handle. Nothing is more effective in getting your foot in the door than taking a well-crafted portfolio of your best images

directly to the director (not the secretary). Make an appointment then walk in the door and shake the director's hand with one hand and offer the portfolio with the other hand. Gallery owners do not rule the world. They need new faces and fresh work. If you get rejected, keep on shaking hands. Somebody will look and listen.

I spent six glorious years exploring the backcountry of the Navajo reservation with a camera as my constant companion. It was a time so rich in adventure and spectacular scenes that I feel blessed to have experienced it. But I found that door, pried it open, and never let it shut behind me. One of the ultimate attributes of photography is it allows you to explore (in the present moment) everything from the micro to the macro, from insects to stars, from people's faces to abstract interpretations of life and beyond. Few mediums offer such a wide choice of expression.

After my time on the reservation ended, I moved to the tiny hamlet of Bluff, Utah. The landscape and the rich source of prehistoric sites was the attraction. The obvious problem (in a town of 250 people with a seasonal tourist business) was how to make a living. I relied on former clients by offering selected images at a discount and eventually opened up CloudWatcher Gallery (which I still operate). I slowly began to strengthen the client list and obtain a presence in the art business. I continued to do exhibitions but stopped about 10 years ago to devote more time to painting and sculpture. I often combine photography with mixed media work. The time away from the show circuit proved the right decision, as I now have a body of work that is completely my own.

The move to Bluff is a case of extreme decision-making in order to connect with the land. I had Monument Valley, Cedar Mesa, Valley of the Gods, and Canyonlands as my backyard. So quite naturally I spent more time in the field than marketing. The first 12 years in Bluff were spent hiking the canyons with a camera. I learned to do with less to continue this unusual lifestyle. I maintained a low overhead and often saw my bank account as transparent as plastic wrap,

but I was where I wanted to be and I stuck with it. As the saying goes, "Be careful what you ask the gods because they may give it to you."

I believe that when one takes on the mantle of an artist there will be times that you will question your sanity. You may get public accolades, make some sales, but there will be those dark times when you may wish you had listened to your parents and keep that accounting job. You must take a serious look at yourself, your art, and make a commitment to pursue that path but with a heightened sensitivity to what is working and what is not. Following your bliss (a famous maxim by the late Joseph Campbell) is not always a pathway strewn with roses. It is more akin to the hero's journey with all the trials and obstacles that life throws at you on your quest for the Golden Fleece. One must keep that flame burning and no matter how dark the forest is, know that you are on the right path and there is a light at the end of the proverbial tunnel. You may have to pick your own self up by the bootstraps and keep on moving. There are many helping hands out there but do not rely on that to get you where you want to go. If, indeed, you know where that is.

As a result of making photography or art a life process, all of my pieces have a story. And that is the critical element that sells my work. People want the story, a deeper connection than just a beautiful or intriguing piece of art. When you get a few public exhibitions you will see how this works. Beautiful work can sell itself, but a story will keep them coming back for more. You have to know how to read people and recognize what they are about in just a few words. And most importantly, know when to back off and let the work speak for itself. That is a skill that comes from experience.

I have been in the gallery business for over two decades. I have seen a lot of people come and go, and I pay close attention to what they are interested in. In my domain, color landscapes reach a broad audience. The work connects them directly to the environment they are visiting. The market for black-and-white work is narrower. The people who collect black-and-white photographs exclusively are different than the former in several ways. As you move along into abstract work, mixed media, or more personal interpretive work, your clientele is even narrower, and so is your market. And if you merge into another medium, such as painting and sculpture, you have reached a different audience and the market for that is paper-thin but usually with more zeros on the sales slip. I make a living off a wide range of work in type and price range, but my situation is very unique. Since I live in a town of only 250 people, I depend on impulse buyers and former clients. I have to hustle to make ends meet and cannot rely on anyone else but me.

I believe that success in anything comes from baby steps, not quantum leaps. Usually those who make these quantum leaps are a one-hit wonder. They do not

possess the substance to be persistent in order to endure the trials of a creative life. You will make breakthroughs and find success if you have a strong work ethic and stick to your vision. There are many people out there who can offer advice, and all of us—no matter how many one-man shows we've had—can benefit from a coach. Art, regardless of the medium, comes from the heart. You must learn your tools and work diligently, but you can never let any technique or piece of equipment distract you from a pure vision, a dynamic connection with your chosen subject.

So, to end this story, I hope that you can extract some words of wisdom from this text and store them for later use. I still think about things I have read or heard over 40 years ago. You are never too old to learn, and not everything should be taken too seriously. Having fun with your camera is as important as seeing prints on the wall with red 'sold' dots by them. When Ansel broke his nose in the 1906 San Francisco earthquake, the doctor informed the young man that it should be repaired when he matured. Fifty years later, as I watched Ansel riding his three-wheeled trike around in circles in his Carmel driveway with his still-crooked nose, he looked over at me, smiled, and said, "I have never matured."

Contact Information
Website: www.cloudwatcherstudio.com
Email: J.R.lancaster_art@yahoo.com

Skill Enhancement Exercises

What do you like in J.R.'s approach to marketing his work?
What do you not like in J.R.'s approach to marketing his work?

Make a list of what you see as being the strong and the weak points of J.R.'s marketing approach. Once that list is complete, make decisions about what you can use from this artist's approach and write a list:

- ❯ What do you see as being useful for your own marketing approach?
- ❯ What do you see as not being useful for your own marketing approach?
- ❯ Is there anything missing from this artist's marketing approach? If yes, what is it?

Moonset at Sunrise, Zabriskie Point, Death Valley, California © Alain Briot ▶

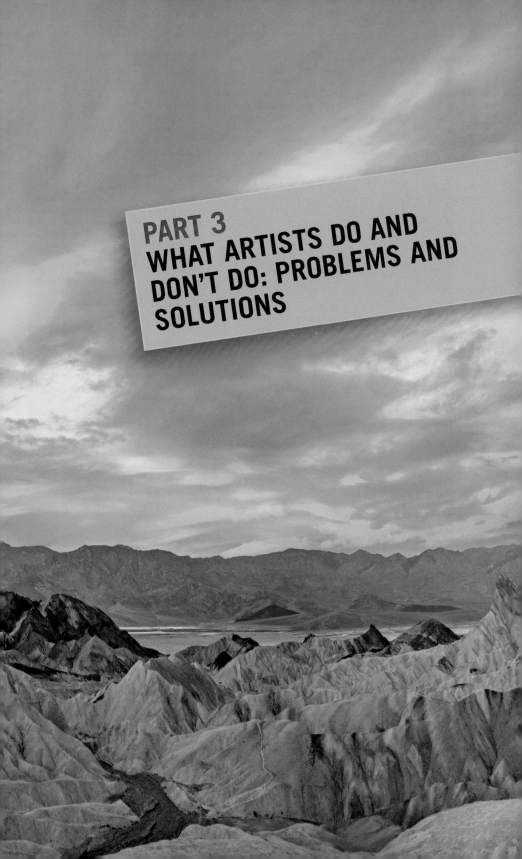

PART 3
WHAT ARTISTS DO AND DON'T DO: PROBLEMS AND SOLUTIONS

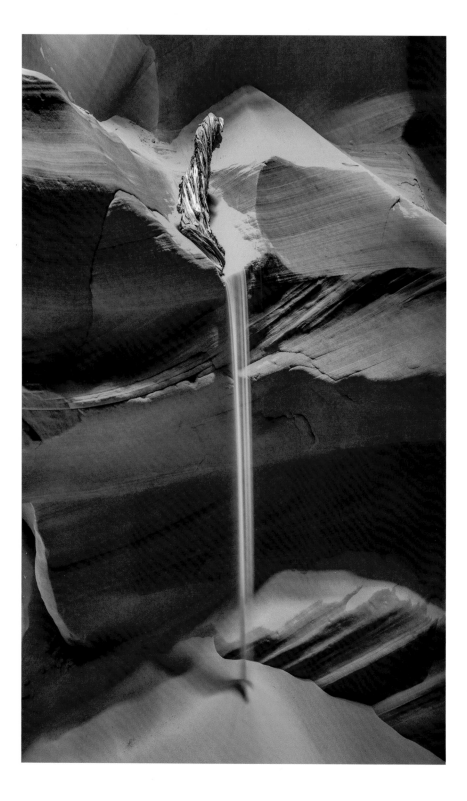

Introduction to Part 3

*The person who makes a success of living is the one who sees his goal
steadily and aims for it unswervingly. That is dedication.*
CECIL B. DEMILLE

This part features a collection of real-life stories about things that artists do,
either rightly or wrongly. Each brief, to-the-point story features a descrip-
tion of a marketing problem encountered by an artist and the solution to
the problem.

The goal of these stories is to show you examples of things that artists
frequently do, and to provide you with an opportunity to learn from them.

Story 1
Maria: Pricing

Picture yourself in your mind's eye as having already achieved this goal.
See yourself doing the things you'll be doing when you've reached
your goal.
EARL NIGHTINGALE

The Problem

Maria priced her masterpiece at $300,000, a six-figure price. However, she priced her study for this masterpiece at $3,000, a four-figure price. The huge discrepancy in pricing—the price of the study being only one percent of the price of the masterpiece—creates problems. Prospective buyers question why the study is priced so low and wonder about the validity of the pricing of both the masterpiece and the study.

The fact that a five-figure, intermediary, price is missing adds to the problem. This triggers many questions in the mind of the customer. Why is there such a dramatic jump in price? Is the study underpriced? Is the masterpiece overpriced? Are the two pieces priced to sell to different audiences—for example, a wealthy and a less wealthy audience—instead of being priced for their intrinsic value? Is the artist hoping to sell the study by overpricing the masterpiece? Is the study an investment opportunity or a poor investment?

The Solution

Maria needs to price her study in the five-figure range, for example, $30,000, which is 10 percent of the masterpiece price. Having the study and the master-piece one price level apart (five and six figures, respectively) makes the pricing logical and silences the customers' questions.

Story 2
Jane: Negotiating

Nature does not hurry, yet everything is accomplished.
LAO TZU

The Problem

Negotiating can be a challenging process. To be a successful negotiator, it is best to leave your emotions and your ego at home. In this example, we are going to see how emotions can ruin a potentially lucrative negotiation and how this problem can be solved.

Jane is offended by the low $2,000 offer that a collector made for one of her paintings, which is priced at $5,000. She responds rather rudely: "I can't sell this piece for less than $3,000." The collector does not appreciate her tone of voice and her unwillingness to work with him, even though $3,000 is a price that is very close to what he had in mind. He walks away and Jane loses the sale.

The Solution

Jane should have been more affable and diplomatic and, for example, said something like: "I am willing to offer you this beautiful piece at only $3,000. That's an excellent price, and I do not normally negotiate this low. But I want to help you because I see that this piece talks to you. How do you feel about taking this piece home today at this low price?"

Story 3

Kent: Praise vs. Sales

If we could sell our experiences for what they cost us,
we would all be millionaires.
ABIGAIL VAN BUREN

The Problem

Kent went to a photography symposium and showed his photographs by projecting them onto a large screen. His image of an HDR-processed dilapidated truck generated oohs and aahs from the audience. The photographers at the symposium loved it and were not shy about expressing their admiration. Kent even won an award for one of his photographs during the symposium.

Back home Kent decides that since his work received such acclaim he is ready to set up a photography business and start selling his work. After much preparation, printing, framing, matting, pricing, and preparing his booth, Kent finally has his first show. To his dismay, nothing sells, and the photograph that generated such acclaim at the symposium hardly gets noticed by the show visitors. Kent is disappointed and concludes that people at that show have no taste and don't know good photography when they see it.

The Solution

The problem Kent faces is that he is confusing praise and sales. What he received at the symposium was feedback on the quality of his work. The praise that was bestowed on his photograph was not indicative of the selling potential of his work and did not take into account his salesmanship and marketing skills. Also, he did not ask anyone to buy his work, and if he did, it is unlikely that he would have found a buyer.

What Kent received at the show was feedback on the salability of his work and on his salesmanship and marketing skills. The show visitors did not find his work attractive enough to purchase it, and his marketing and salesmanship skills did not help change their minds.

◄ *Monument Valley Avant Garde* © Alain Briot

Don't confuse praise and sales. If I received a dollar each time someone told me that my work is beautiful, the balance on my bank account would be higher than it currently is. Unfortunately, liking something and buying it are two very different things, and being misled into thinking that your work will sell because people like it is a common mistake among artists.

Story 4
James: Not Needing the Income

*The beginning of knowledge is the discovery of something
we do not understand.*
FRANK HERBERT

The Problem

James is a highly qualified professional in the medical field. He loves photog-
raphy and considered selling his work. However, he realized that selling his
work means starting a business and doing all sorts of things that have nothing
to do with photography, such as accounting, marketing, salesmanship, dealing
with customers, negotiating, collecting sales tax, shipping, and dealing with
inevitable business problems. James also realized that being in business meant
having business-specific expenses, such as insurance, taxes, licenses, show fees,
inventory costs, shipping expenses, and more. Finally, James did not need to
generate income to support his hobby and he realized that selling his work was
a matter of personal growth and satisfaction rather than a financial necessity.

The Solution

James considered all these facts and decided that starting a photography busi-
ness would take the fun out of photography rather than generate new rewards.
Therefore, he decided to show his work only for fun, without having anything
for sale. Showing his work to friends, family, relatives, coworkers, and other
photographers was rewarding enough in itself. Occasionally, James would donate
or exchange one of his pieces.

What James understood is that he wanted to show his work to share his
passion for photography, not to make money. For this he did not need a business,
he just needed a place to show his work. Since he had a large house, he decided
to have intimate shows in his home once or twice a year. If he needed a larger
space he could rent a conference room in a nice hotel, rent space in a gallery for
a week or a weekend, or show his work at his country club. This arrangement
provided all the rewards he was looking for and served as motivation for James

to continue photographing for many years. It also alleviated the expenses and the stress associated with running a business.

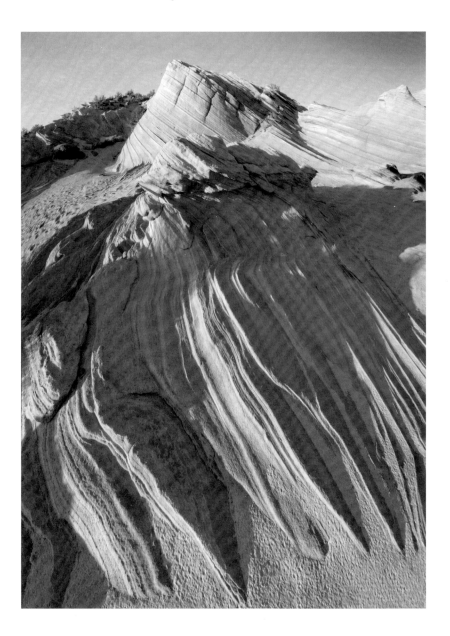

Sandstone Waves Black and White #1 © Alain Briot ▲

Story 5

Marie: A Successful Show

Nothing is a waste of time if you use the experience wisely.
AUGUSTE RODIN

The Problem

Marie decided to sell her work at art shows. She wasn't sure how to get started, but she knew she did not want to invest in equipment that she may not keep. She also did not have much money and was therefore concerned with minimizing her costs.

The Solution

Instead of buying equipment, Marie decided to use what she had available and she borrowed what she did not have from a painter friend who had done art shows in the past but was now taking a break.

Her show booth was simple: she used the show tent, ProPanels, and bins that she borrowed from her friend. She brought her own table and chair. Her display was equally low-key, with a few framed pieces and a small inventory. She knew she did not have as much as other artists, but this was a start and it was better to jump in with what she had rather than wait until she had everything she wished for.

There were things Marie did that did not cost her any money. First, she announced her show to all her friends, both over the phone and via email. Second, she practiced her salesmanship skills by rehearsing how to greet and talk to customers, and how to respond to their questions, stalls, and objections. Third, during the show she gave discounts for purchasing on the first day of the show and for purchasing multiple pieces. She also collected contact information both from actual and potential customers.

Even though this was her first show and even though her display was less than perfect, the result was excellent. Marie's sales were strong and her minimal investment meant that she turned a profit on her first attempt at selling her work. She also started building a contact list of people to whom she will market her products, send special offers, and invite to her future events.

Story 6

John: Fish Marketing

The first requisite for success is the ability to apply your physical and
mental energies to one problem incessantly without growing weary.
THOMAS A. EDISON

The Problem

John sells underwater photographs of fish. Being a diver who regularly visits
some of the finest and most exotic locations in the world gives John expert
access and knowledge that are unavailable to most people. While on diving
expeditions John collects the email addresses of people who are interested in his
work and adds them to his email list. He also sells his work at art shows where, in
addition to making sales, he also collects email addresses for his list.

While trying to sell his work, John became aware that his photographs cannot
be sold on the basis of the location, or the fish species, because for the most part
his customers are not familiar with either. The question, then, became how to
make customers relate to exotic fish and locations they may never have heard of
prior to seeing his work.

The Solution

To remedy this problem John designed a marketing program with the goal of
helping customers relate to his fish photographs by making the fish part of their
lives. John decided to market his underwater fish photographs as if they were live
fishes. He also decided to call his business Fish on Your Walls. In his marketing
materials, John explains the advantages of having fish on your walls instead of
having them in an aquarium: you don't have to feed the fish, clean the aquarium,
or change the water. If you go on vacation, you don't need to hire someone to take
care of your fish. Finally, you don't need to know which fishes eat which other
fishes. In his email newsletter, which is sent to his customers twice a month, John
expands on this list by adding new advantages.

To help people visualize how to decorate their homes with fish photographs,
John prepared a series of example images showing his photographs framed and

displayed over a couch. These photographs show how the room looks with a single, medium-size photograph; a very large photograph as wide as the couch; and a series of nine small photographs over the couch organized in rows that are three prints across and three prints high. For each example John has a limited-time special offer. The special offer is available for only two weeks each month. In the future John plans to expand on his offers by showing how his work can be used to decorate other areas of the house by placing it over different types of furniture, such as a bed, a mantle, or a buffet.

This marketing plan requires planning, preparation, implementation, and follow-up. It is a lot of work, but it is allowing John to sell his work regularly instead of waiting for his photographs to sell themselves.

Story 7
Sylvie: A Lack of Promotion

Everybody gets so much information all day long
that they lose their common sense.
GERTRUDE STEIN

The Problem

Sylvie has been selling her work at art shows for many years. She is getting older, and shows are getting tiring because of the constant travel, the long hours, and the physical work required to set up and take down the show. She is ready for a change, and she is looking for a way to sell her work that is less physically demanding and that does not require constant travel.

Sylvie believes that the web is the solution to her problems, so she built a website where she offers her work for sale. She has a wide selection of her landscape photographs in various sizes and a shopping cart.

During the many years that she did shows, Sylvie built an email list. To promote her work, Sylvie signed up for an automated email service. When someone signs up for her newsletter, this person receives her newsletter automatically. Though the email comes from Sylvie, it is sent automatically by her email server. Thereafter, Sylvie sends a different newsletter to her subscribers once a month.

However, Sylvie does not include a limited-time offer in her newsletters. Nor does she offer incentives, promotions, or other purchasing motivators. As a result, Sylvie is not selling her work through her email newsletters. In fact, her web sales are nonexistent and she must continue to depend on selling her photographs at art shows to make a regular income.

The Solution

The lack of buying incentives in Sylvie's emails is the cause of her problems. Sylvie needs to include promotions and special offers in each of her emails in order to generate sales. If people are not given a reason to make a buying decision now, they will delay making a purchase indefinitely. For example, Sylvie can offer a 20 % off, limited-time special offer in her email newsletters. Doing so will give her customers a reason to buy over the web.

Story 8

Berndt: The Flower of the Day

It has been my observation that most people get ahead during the time that others waste time.
HENRY FORD

The Problem

Berndt sells flower photographs on the web and at art shows. On his website he offers a free subscription to his email newsletter. After signing up, subscribers receive a different flower photograph each day via email. Berndt calls this marketing technique the Flower of the Day.

Potential customers are happy to get their Flower of the Day, and the repetition keeps them thinking of Berndt and his beautiful work. However, Berndt does not provide any buying incentives to his subscribers. While they enjoy receiving a new flower photograph every day over email, they have no reason to buy his photographs. Plus, why would they buy a photograph since they are getting a free one every day?

The Flower of the Day is a lot of work for Berndt; he has to create 365 photographs each year just to fulfill the needs of his newsletter subscribers. Sending a daily newsletter is also expensive because he has a large number of subscribers and he pays for the email sending service. Unfortunately, there is no way that Berndt can send individual emails himself everyday. If he did, he would have no time to do anything else!

The daily emails Berndt sends to his customers end up being too much. It annoys them and one-by-one they unsubscribe from his newsletter. Instead of making his work exciting, Berndt's emails come across as spam and are no longer welcome.

Berndt's problem is somewhat comparable to Sylvie's problem, which we looked at in story 7. Just like Sylvie, Berndt's email marketing approach is ineffective. In addition to alienating his customers, it also ends up being too costly and requiring too much work. Eventually, Berndt has to discontinue his daily emails.

The Solution

To try fixing the problem, Berndt starts to send a monthly newsletter instead of a daily newsletter. However, by then most of his subscribers have unsubscribed from his newsletter. Those who are left start unsubscribing too because they are no longer getting their Flower of the Day. In the end he is left with just a few subscribers, not enough to have a successful email marketing campaign.

Berndt needs to keep his emails to one or two a month, no more, unless he has a special event to announce such as a yearly show. No matter how much people like his work, we all have a limit as to how much we can take. Daily emails are just ineffective when it comes to marketing. To regain customer confidence Berndt needs to stop the Flower of the Day and start doing a Flower of the Month instead. He can also offer a limited time special for the Flower of the Month to make it more attractive and to increase sales. However, Berndt will also need to find new email subscribers because it is too late to bring back the confidence of his previous subscribers.

Mobius Arch and Moon © Alain Briot ▲

Story 9
Craig: From Commercial to Fine Art Photography

Failure is the opportunity to begin again, more intelligently.
HENRY FORD

The Problem

Craig has worked as a commercial architectural photographer for 30 years. He has had a successful career and he is proficient in marketing. He has also developed a rather large customer base, with many repeat customers who regularly hire him for photography services.

Considering a move from commercial to fine art architectural photography, Craig decides to create a series of fine art architectural photographs, focusing on the downtown district of the city where he has most of his clients.

The Solution

As he begins to work on this project, Craig contacts his clientele located in the downtown district he is photographing. He describes his project and offers them the opportunity to join the project as sponsors.

Being savvy in marketing, Craig has prepared three different packages that sponsors can choose from. These packages offer the options of an introductory, a midrange, and a high-end financial participation. Sponsors receive specific rewards for sponsoring Craig's project. These rewards are commensurate with their level of participation. Introductory level sponsors receive four 16"×20"matted prints. Midrange sponsors receive twelve 16"×20" matted prints. High-end sponsors receive twenty-four 16"×20" prints, matted and framed.

Craig's project is quite successful because his clientele can relate to the subject he is photographing. As a result Craig secures many sponsors.

When his project is complete, Craig organizes a show of his work in the lobby of one of the downtown corporate buildings he photographed. The corporation that owns this building is one of Craig's sponsors. Craig invites decision-makers

of corporations whose offices are located in the downtown area to his show. Many show attendees purchase photographs of their own buildings and of other downtown buildings. Later, they exhibit Craig's photographs in the hallways of their corporate offices, as well as in private offices and in a few instances in their own homes. In turn, these photographs generate additional sales to the people who see them.

Craig's planning, hard work, and carefully orchestrated marketing efforts are paying off. As a result, his career as a fine art architectural photographer is off to a good start.

Story 10

Jay: Doing Anything to Make a Sale

Marketing is a very good thing, but it shouldn't control everything.
It should be the tool, not that which dictates.
NICOLAS ROEG

The Problem

Jay has been trying to sell his work, unsuccessfully, for years. After moving to a new location, Jay approached one of the local art galleries to seek representation. After seeing his work, the gallery owner told him that even though he is very talented, his style of work would not sell in her gallery because it does not fit in with the style of the other artists she represents and because it is not what her collectors are looking for.

Depressed by this news, Jay told her that he could photograph any subject and create pieces in any style she wants. "Just let me know what you want and I will do it," Jay explained.

Upon hearing this, the gallery owner told Jay she might contact him later on but that right now his work is just not the right fit for her gallery. In reality, learning that Jay is willing to do anything to make a sale has turned her off forever from taking an interest in Jay's work. As an art connoisseur, she values passion and integrity, and she has esteem for artists who stand up for their style, not for those who are willing to do anything to become popular.

Jay's attitude, rather than his current work, is what turned her off. She realized that he is simply not willing to stand behind his style, and this is exactly the opposite of what she is looking for in an artist.

The Solution

Jay needs to stop trying to do anything to make a sale or to please everyone he interacts with. When his attitude changes, his level of success will increase. But if he continues to have his current attitude, he will continue to meet people who are not interested in working with him.

Story 11

Jean: Visiting Shows

I'm not a marketing person. I don't ask myself questions. I go by instinct.
KARL LAGERFELD

The Problem

Jean wants to sell her work at art shows. The problem is that she does not have any experience doing shows and therefore does not know what to expect.

The Solution

Jean decides to visit several art shows that are taking place in the area where she lives. Jean is not planning to sell her work at these shows. Her goal is to go to the shows and see how things are done, what type of artwork is sold, and how artists are pricing their work.

Jean visits four different shows in her area. By looking at a variety of different artists' booths, all selling photography, and by comparing what each of them is doing, she is able to piece together a comprehensive picture about how artists approach art shows. She finds out, for example, that certain types of pictures, subjects, and sizes are seen in most artists' booths. She also finds out that prices cover a specific range, from high to low, in her area. By taking notes about prices, subject matter, and sizes, she is able to find out what the lowest and the highest prices are, what subjects people like, and what sizes are the most popular. This information gives her a good idea of how to price her own work, what subjects to feature, and what sizes to offer.

Jean is also able to talk to several of the artists. While some prefer to talk to customers only, others are willing to give her pointers on how to get started and on what she needs to have for her first show.

All in all, Jean's learning experience visiting art shows is positive. While there are numerous things she can learn only through trial and error, or by talking to a consultant who has experience doing art shows, she is able to take some of the fear out of trying shows for the first time. She also came back from visiting the shows with a better appreciation of what it will take to be successful selling at art shows and of how much time and effort doing shows successfully will require.

White Sands Sand Storm © Alain Briot ▶

144

PART 3
..
STORY 12 ROBERT: WORKING WITH GALLERIES
..

Story 12
Robert: Working with Galleries

In marketing I've seen only one strategy that can't miss —
and that is to market to your best customers first,
your best prospects second, and the rest of the world last.
JOHN ROMERO

The Problem

Robert wants to sell his work in galleries. The problem is that he has no experience submitting his work to galleries or working with galleries. He also does not know which galleries are appropriate for his work and which ones he should contact first.

The Solution

Rather than take a blind approach to submitting his work, Robert decides to start by visiting galleries, seeing what they sell in regard to photography, and speaking to the gallery owners about the best way to submit his work.

Using an online search to get started, Robert selects five galleries located in his area, making sure these galleries sell fine art photographs. Robert then visits each gallery, intentionally going on a weekday so that the galleries are less busy and the owners have time to talk to him.

Robert does not take any of his work during this initial visit. However, he does take business cards so that he can leave his information with the gallery owners if asked. Not having his work with him goes a long way toward lowering Robert's stress level. Since he is not going to show his work, he is not going to be exposed to the possibility of being rejected by the galleries.

While visiting the galleries he selected, Robert is able to see the type of work being sold, as well as the types of framing, the sizes, and the subject matter that are popular with galleries in his area. By talking to the gallery owners, he is able to find out what they expect from him in regard to seeing a selection of his work. He learns how many pieces he needs to bring, what sizes, and what presentation, together with which information is important for the gallery owner to have and which information is not important to them.

After putting together a portfolio of his work, consisting of gallery sheets featuring his photographs with the relevant information, Robert schedules personal meetings with the gallery owners who showed interest in his work. After meeting with them, Robert is accepted in two galleries that are excited to represent him.

Robert's success shows that preparation and having a plan of action play an important role in generating a positive outcome to a new endeavor. Rather than directly going to galleries and showing his work without knowing what to expect, Robert took things one step at a time and by doing so maximized the possibilities of being represented by a gallery. This successful endeavor gave Robert a positive outlook on his budding artistic career.

Story 13

Jerry: A Kickstarter Project

I like involved projects.
TORI AMOS

The Problem

Jerry photographs landscapes in the eastern United States and wants to create a limited edition folio of his work. Jerry also wants to offer matted, open edition prints of the photographs featured in the folio. To sell his work and cover the costs associated with creating the folio and prints, Jerry decided to start a Kickstarter project.

Kickstarter is a crowdfundraising website through which individuals seek funding from backers for creative projects. The project creator must set a funding goal and a deadline, and then offer donation options ranging from a low to a high dollar amount. Only if the funding goal is reached or exceeded by the deadline, will the project get funded. Funding on Kickstarter is all-or-nothing: projects must reach their funding goals to receive money.

Backers make pledges using a credit card. If the project does not reach its minimum funding goal by the deadline, the backers' credit cards will not be charged and the project creator will get nothing. If the amount of funding sought is reached by the deadline, Kickstarter will charge the credit cards, take 5% of the funds raised, and send the rest to the project creator.

In this instance, Jerry is seeking to fund a specific project: a limited edition folio of 12 images of Eastern United States landscapes plus a collection of matted prints. Jerry's folio is letter size, contains 12 photographs, an artist statement, and a biography, and is presented in a custom-made folio enclosure. Jerry set a variety of pledge options for backers, and various rewards are offered to thank the backers according to their level of support.

For his Kickstarter project Jerry set a funding goal of $1500 with pledge options ranging from $1 to $85, as follows:

◄ *Sunset Near Lake Powell, Arizona* © Alain Briot

Donation	Reward
$1	Backer receives a thank you note
$5	Backer receives a greeting card
$25	Backer receives one 8×10 matted print from the folio
$40	Backer receives five 8×10 matted prints from the folio
$85	Backer receives the complete folio

Unfortunately, at the end of the funding period, Jerry only received $1,000 in pledges. As a result, his project did not get funded.

Jerry failed to reach his funding goal primarily because he set his Kickstarter project funding levels far too low. Jerry's audience is small, so there simply were not enough people funding each level to make the project successful. In addition, only the top backing level was rewarded with the folio. Since this project is about creating a folio, the folio should have been a reward available for all funding levels.

Even though he reached two-thirds of his goal—$1,000 instead of $1,500—Jerry received no money because of Kickstarter's all-or-nothing policy.

Jerry's experience shows the importance of carefully planning the funding levels of a Kickstarter project. The best way to do this is to make a realistic estimate of the size of your audience. For example, can you expect 10, 100, 1,000, or more backers?

It is also important to evaluate the range of support your audience can offer. For example, at which level can you expect most backers to be comfortable funding your project— is it $10, $100, $1,000, or more? Finally, it is important to set your Kickstarter funding levels accordingly. Although these variables will differ from one photographer to the next, there are certain rules that apply across the board, and these are the fundamental rules of marketing. It is by applying these rules to Kickstarter that we can find a positive solution to Jerry's problem.

The Solution

Jerry did not get discouraged and he plans to start a second Kickstarter funding campaign at a later date. When Jerry designs his next Kickstarter project I recommend that he do two main things: (1) restructure his funding levels, and (2) make his rewards more exciting and appealing. Here are my suggestions:

- Set the lowest funding level at the cost of the folio: $85
- Set the highest funding level significantly higher; I suggest $1,200
- Adjust what rewards are given for each funding level

When doing a Kickstarter project you can expect to get the most funding in the middle funding levels. This is the same as offering a product in small, medium and large sizes; the most popular size is usually the medium size.

Looking back at Jerry's original Kickstarter project, the $25 middle funding level did attract the most backers. The lowest and highest levels got far fewer backers. If Jerry raises his entire range of funding levels, he will by the same token increase the middle funding level. For example, setting the middle level to around $300 means that only five backers will be necessary to reach his funding goal, provided all backers select the mid-range level. However, we know that some will choose lower funding levels and that some will select higher funding levels, hence the importance of offering attractive rewards for all levels.

This new approach almost guarantees that Jerry's project will be funded if he keeps his funding goal of $1,500. Of course, if he increases his funding goal, he will have to raise the entire range of funding levels proportionally.

With these changes, I suggest the following Kickstarter funding options and rewards:

Donation	Reward
$85	A folio
$150	A folio and an 8×10 matted print
$250	A folio and an 11×14 matted print
$350	A folio and a 16×20 matted print
$600	A half day spent photographing with Jerry, a folio, and a 16×20 matted print
$1,200	A full day spent photographing with Jerry, a folio, a 16×20 matted print, and dinner with Jerry

The last two rewards shown above should be available to only one donor for each level, thereby increasing their value and desirability. Regarding matted prints, the backers will be free to choose the print they want to receive among any of the 12 images in the folio.

Using this approach, it is likely that Jerry will get the $1,500 he needs to fund his project. In fact, he may very well exceed his funding goal.

Another solution is to use a different funding site, one that does not require the project to be fully funded to collect the money. Indiegogo offers such an option. If Jerry had funded his project through Indiegogo, he could have collected the $1,000 funded by backers, even though his original $1,500 funding goal had not been reached. The only caveat is that Indiegogo would have taken a bigger

cut of the money transferred than if the project had been fully funded. However, since the risk is reduced, paying a higher percentage may be better than getting no money at all.

Kickstarter and other online funding websites are often seen as a way to raise seed money to start a business or to produce a work of art (for example a motion picture). When used this way, the marketing of the product or business starts after the project has been funded. Jerry's goal is to use Kickstarter to sell his folio to collectors through the funding process. Jerry's use of Kickstarter is different and may be considered a "creative" or alternative use for a crowdfunding website.

Success in marketing, and in business, often comes from being creative. Exercising your creativity gives you ideas that nobody had before. It generates new ways of thinking about an existing project and new ways of marketing a product. It makes your product interesting to potential customers, not just because of the product itself but because of the way it is presented.

Sunrise on the Playa, Death Valley National Park © Alain Briot ▸

Story 14

Mark: Using Flash on His Website

The aim of marketing is to know and understand the customer so well that the product or service fits him and sells itself.
PETER DRUCKER

The Problem

Marks sells his work primarily on his website. His website features Flash animated photographs, including many large photographs that take a long time to load.

Looking at his statistics on his cPanel, Mark notices that his visitors do not stay long on his website and that some even leave his website after spending just a few seconds. He is also not getting any online orders and he is not receiving any email inquiries.

Visitors to Mark's website complained to him via email that his Flash animations were taking forever to load, that they did not have the patience to wait, and so they moved off his site without seeing his work. Also, visitors who accessed his site using Apple wireless devices could not see the Flash animations because Apple wireless devices do not support Flash, so they would leave his site without having a chance to see his work.

Even though Mark's Flash website was beautifully designed, another problem was that since Flash is invisible to search engines, it was not being indexed or ranked by search engines.

The Solution

Mark's decision to make a change was motivated by the feedback he had received from his web visitors. Mark decides to stop using Flash to show his photographs on his website. After modifying his pages, Mark notices a significant increase in the length of time people spend on his website and in the number of orders placed on his site.

The first page on Mark's original site featured a single full-page photograph on a black background. Visitors had to wait for this page to load before they

could click on the welcome button and access the rest of Mark's site. Here too, people complained that they had to wait a long time before seeing the front page photograph and accessing the rest of Mark's site. The length of the wait period varied according to the connection speed used by individual visitors. While those with fast connections waited only a couple seconds, those with slow connections had to wait several minutes.

Mark replaced his Flash pages with HTML pages. He also removed the greeting page and made his information page the first page visitors see when they come to his website. On this new first page, Mark featured a photograph of himself, a list of the services he offers, and the prices of the various print sizes and packages he sells. Because Mark offers limited editions, he also included a description of how his limited editions are structured.

On his new website Mark also has a biography, an artist statement, essays about his approach to fine art photography, and a subscription button to join his email list and receive his free newsletter. On Mark's new contact page, visitors can click on his email address to send him a message. Mark's email address is also provided at the end of each essay as well as on his biography, artist statement, pricing page, and other pages on his site. Finally, Mark regularly announces news about his work, together with limited-time special offers, promotions, and packages.

Since he made all these changes, Mark's sales have increased significantly and so have the number of people who sign up for his newsletter and who contact him over email. While he needs to continue his marketing efforts, Mark knows that his desire to use Flash to promote his work was preventing him from making sales. He realized that having a quick-loading site with easy access to information, pricing, and ordering pages is essential in making sales on the web. While removing Flash may have taken a bit of pizzazz away from the presentation of his photographs, it made visiting his site more enjoyable and more convenient for his customers.

Mark knows that his competitors are only a click away and that the only way to keep them at bay is to make visitors enjoy his site so they want to spend time there. By being willing to make his site a little less dramatic and impressive in regard to how his photographs are presented, Mark created a user-friendly website that is bringing him business instead of being a slow-loading online gallery.

Arches at Sunrise © Alain Briot ▸

END NOTES

Conclusion

*With integrity you have nothing to fear, since you have nothing to hide.
With integrity you will do the right thing, so you will have no guilt. With
fear and guilt removed you are free to be and do your best.*
ZIG ZIGLAR

Gaining Credibility

The digital revolution makes it possible for anyone to run his or her own business without outside help. We can create and publish a website, write a blog, have a presence on social media sites, create and print our work, advertise it and offer it for sale, and much more without help from anyone, provided we have the necessary technical knowledge, software, and equipment.

This is great because it gives us independence, places us in control of our destiny, and saves us from having to find printers, publishers, web developers, marketers, representatives, agents, galleries, and other service providers that have traditionally helped artists print, market, and sell their work.

The problem is that the same capabilities are available to any artist with the same amount of knowledge, software, and equipment. This situation creates several issues in regard to credibility in the eyes of our audience. Looking at what these issues are is the focus of this essay.

Gaining credibility is becoming one of the biggest challenges faced by both new and existing businesses. The cause of this challenge is that as the world population grows, the customer base, and therefore demand, increases. At the same time, self-marketing possibilities continually increase, fueled by the constant increase in the number of low-cost, easily accessible, self-marketing opportunities offered by the Internet.

We have reached the point where anyone can market virtually any product or service themselves. The challenge is: how do you prove to your customers that you, your product, and your services are legitimate? This is an important question because there is little to prevent unscrupulous businesses from offering fraudulent products through dishonest marketing. As honest business people, how do we prove to our customers that our business is legitimate and is operated with integrity? As customers, how do we find out that a business is legitimate and is operated with integrity? Answering these questions effectively is the key

to generating trust in our customers. Not answering these questions properly, or failing to address them at all, means failing to establish customer trust.

Anyone Can Do This, So What Makes You Unique?

Since anyone can sell their art, what makes you, or any specific artist, stand out? What makes you an expert? In other words, what is unique about you? If we are displaying our art, what are the unique aspects of our work, and if we are selling our work, what is our unique selling proposition (USP)? Having unique aspects is something that preceded the emergence of the Internet. However, the need to distinguish ourselves has intensified in recent years due to the huge increase in artists presenting and selling their work online.

Since We Have Total Control, How Do We Demonstrate Integrity?

Since we are in total control of the contents of our websites, blogs, social media announcements, and so forth, the issue of credibility becomes significant. When publishers, agents, galleries, and other forms of representation mediated the relationship between the artist and the audience, these diverse entities and individuals checked texts and other materials for accuracy. They had to because, as publishers and representatives, they were responsible for publishing accurate information. In other words, they acted as *intermediaries* between the artist and the audience.

Today we can take full control of our destiny if we so desire, and we can do away with all these intermediaries. This means there is no longer someone else responsible for checking the accuracy, honesty, or integrity of what we publish. Instead, we must check all this ourselves. This means we are fully dependent on our integrity and honesty. In order not to deceive the public, and in order to build a trusting relationship with our audience, we need to have total integrity and we must be honest with our audience when we write or publish information about ourselves, our products, or our businesses.

Since No One Needs to Approve Your Presence, Who Says You Are Qualified?

Anyone can decide to open shop on the web. There are no applications to file and nobody needs to give you their approval. In this situation, since anyone can say whatever they want, how do we demonstrate credibility to our audience?

The answer is to present information about our training, our career, and our professional involvement. We need to provide facts and references that can be checked by anyone. We need to explain our professional involvement: how long we have been doing this, who we worked with, what we have accomplished, and so on.

Here is a short list of the information you can provide:

- Document your training and education
- List your degrees or professional training certificates
- State how long you have been doing photography
- State how long you have been in business
- Feature client testimonials
- List significant exhibitions and shows
- List significant industry awards and other forms of recognition
- Describe your professional involvement
- List your publications
- List your membership in professional organizations
- Describe your involvement with other professionals (because we are known by the company we keep)

Write a Disclosure Policy

A disclosure policy is a text in which you list any and all relationships with manufacturers and businesses. Having this policy available to your customers is important because if you review equipment, or receive money from sponsors, you must not let manufacturers influence your opinion. Your debt is to your audience, not to the equipment or the software manufacturers. Your audience expects you to provide an honest opinion. If you violate the trust that the audience places in you, you will lose both your audience and your credibility.

Since Anyone Can Self-Publish a Book, Who Says Your Book Is Worth Reading?

Today anyone can publish a book by themselves. This can be done either via physical printing through a print provider or through digital publishing of eBooks using a variety of software platforms. EBooks are gaining enormous interest right now because they carry virtually no costs (no printing and no shipping are necessary), are paid with credit cards, and can be sold worldwide on a website. Physical self-publishing, on the other hand, carries a much higher cost because the artist has to pay for printing, keep an inventory, and physically ship each purchase.

The problem with self-publishing is that, compared to books produced by publishers, no one needs to give their approval and therefore nobody is there to check what you are publishing. In other words, as with websites, blogs, and social media, we are fully responsible for the content of what we publish.

On the one hand, this is a good thing because we are not required to find a publisher and to go through the rather lengthy process of submitting a manuscript, having it accepted (or not), having it printed, having it published and announced, and so on. This speeds up the process and gives us full control of every aspect of the publishing process.

On the other hand, a publisher lends trust and credibility to the authors that they publish. This is because there are many efforts and expenses involved in publishing a book, and a publisher will not go through these if they do not believe that the book will be attractive to their audience and if they do not value the author's writing. In other words, being published by an independent publisher lends credibility to the author. It is a form of endorsement and as such it carries a significant level of credibility and achievement.

Not so with self-publishing. The only endorsement you need is yours and occasionally that of your family and friends. This means you have to make the audience trust that your writing is interesting and that your book is worth buying. Here too it is your responsibility to create a trust-based relationship between you and your audience. This problem was traditionally taken care of by publishers. Now it has to be taken care of by the writers and the artists themselves.

Since Anyone Can Set Their Own Prices, Who Says That Your Prices Are Accurate?

In the days when galleries, representatives, publishers, and so forth set prices, they once again acted as intermediaries between artist and audience. They were

responsible for setting accurate prices for the work of individual artists. Today, when we sell our work ourselves on the Internet, at shows, and elsewhere, this responsibility falls on us. However, our prices still need to be set accurately. While a certain amount of price fluctuation is expected, our prices cannot be overly low or overly high. They also have to be in tune with the quality of our work and with how much leverage we have.

Prices in art are determined by several factors: the artist's level of recognition, the artist's leverage, and the type of work being sold. The following is a discussion of these factors.

Level of Recognition

The level of recognition is covered in part through the list of professional information that I covered earlier. This list has two purposes: listing your professional accomplishments and providing justification for your pricing. Understandably, the work of an artist with a significant level of professional recognition and accomplishment is expected to sell for higher prices than the work of an artist who is just starting his or her career.

Leverage

The artist's leverage is in part based on his or her level of recognition. An artist with a high level of professional recognition can reasonably expect to have more leverage when setting prices for his or her work.

However, other factors come into play in regard to leverage. One of these factors is the collectability of this artist's work. This applies primarily to artwork, although it can also extend to books featuring the artist's work, or books offered as a print and book set. The work of an artist who is widely collected, and whose work may be numbered, is expected to generate higher prices than the work of an artist who is not collected much, and whose work is not numbered.

Type of Work

The type of work being sold is a significant factor in determining pricing. A work of art offered in a limited edition is expected to be priced higher than a work of art offered in an open edition. Similarly, a portfolio featuring a collection of prints will

be priced higher than a single print, provided that the size and the presentation are comparable. The size of the work also has an affect on prices: large pieces sell for higher prices than small pieces.

The quality of the work is an important factor in regard to pricing. A loose print, made by a photo lab, not signed by the artist, and shipped in a tube, is expected to be priced lower than a print made by the artist, hand-signed, mounted and matted to museum standards, and shipped flat with professional packing.

The collectability of the work is also an important factor when it comes to price. Pieces with limited editions that have run out, or pieces that the artist no longer offers, may fetch higher prices if they become available for sale. Or, they may set a precedent for a specific price point. It all depends whether there is a secondary market for this artist's work, and if older pieces are in demand or not.

Finally, pricing must differentiate between original work and reproductions. The problem is that today some artists use the same printing technology for both originals and reproductions. Some artists also hand sign both originals and reproductions. Both of these approaches are mistakes that must be avoided in order to maintain pricing integrity and collectability because reproductions are expected to be priced far lower than original work.

All of these factors combine to set a price point for an artist's work. As I mentioned previously, a certain level of variation in any given price range is expected. However, gross pricing mistakes must be avoided because they will generate distrust on the part of the audience. This distrust, in turn, will result in a loss of sales. It can also damage your reputation.

Gross pricing mistakes can go either way: one can greatly overprice the work or one can greatly underprice the work. For example, a recognized artist offering quality work in limited editions is not expected to sell his or her work for peanuts. Therefore, if this artist's original work sells for below, say, a hundred dollars, the audience will, understandably, be suspicious. They will think something must be wrong here—either the quality is substandard, or the edition is larger than they were told, or something else is amiss.

Similarly, an artist who is just starting out is not expected to price his or her work at, or above, the prices of a recognized artist whose work is collected by a large audience. If an artist who is starting out prices his or her work at a level that is above their heads, so to speak, the audience will question their pricing. Is the artist overly pretentious and arrogant? Is this a get-rich-quick scheme in which the artist makes a fortune overnight then skips town? Here too, the result is usually a lack of sales and endorsements because people in the know are understandably wary of such actions.

The Character of the Artist

Defend your reputation at all costs.

In the end, your credibility is dependent on the integrity of your character, on how you come across to your audience. Character integrity is built over time through repeated actions. This means that to demonstrate character integrity you have to do the right thing, repeatedly, over a long period of time. It is important that you demonstrate through your actions what you talk about in your writings, on your blog, on your website, in your artist statement, and in the other documents that you publish and provide to your audience.

In doing so, there are key elements that are worth keeping in mind. First, when dealing with your audience, you want to be *helpful* instead of being *right*. If you wish to debate a point and present your opinions, you are far better off doing so in your writings, on your blog, or in your artist statement. However, when answering questions from your audience it is best to be helpful. Many people are not familiar with art and therefore have preconceived ideas about it. Proving them wrong is not the right thing to do. It is far better to help them understand art better. You are the expert, so use this type of situation as an opportunity for teaching, not an opportunity for proving people wrong.

It is important to know what to do when someone criticizes your work. This is a complex subject on which I wrote about previously, and I don't want to repeat myself here. All I want to say is that criticism and art go hand in hand. If you have not received criticism yet, you will. You simply were lucky so far, or you did not show your work to enough people yet.

Believe me, criticism will come your way and when it does the worst type of response you can have is frustration, anger, or some other demonstration of resentment. The proper response is tolerance and having a thick skin. Don't blame people for having an opinion different from yours, and remember that your opinion of yourself and of your work rests with you, not with your audience. Therefore, only you can cause yourself to get angry at what you consider to be undeserved criticism.

Just because somebody challenges the value of your work is not reason enough to lose your cool. Keep in mind that the majority of criticisms are opinions rather than facts. Also remember that art, by nature, polarizes opinions. In other words, people tend to either love or hate specific works of art. Therefore, rather than throw oil on the fire by taking sides, act as a moderator by taking stock of the various opinions that come your way. In other words, take count rather than

take sides because this approach prevents you from getting emotionally involved. If you do so you will be fine, even when confronted with the harshest critics.

More people practice photography as a hobby than as a profession, and the entry barrier is low. Therefore, it is important to gain credibility through professional achievements, establishing fair policies, having a stellar track record, and having demonstrated integrity over a long period of time. In regard to business, a track record of being in business for many years along with an excellent reputation is the most effective evidence of integrity you can ever have. In regard to your artistic career, one of the most important achievements is the completion of successful projects together with their publishing, exhibition, awards, and sales. These, plus the presence of a full-disclosure integrity statement on your website and other selling locations, is the best approach to gain your audience's trust and to establish your business reputation.

Epilogue

The time for action is now. It's never too late to do something.
ANTOINE DE SAINT-EXUPERY

A Starting Point

This book is designed to teach you how to sell your work by showing how other photographers market and sell their work. However, it is only a starting point. It is not designed to cover every aspect of marketing. There are countless aspects of selling your work, and each selling and marketing situation has unique characteristics that call for unique decisions. Covering all these characteristics and all the decisions they entail is unfeasible.

Where to Go From Here

If you need information that is not in this book, or if you need help with a personal situation, I offer additional learning opportunities through my other book on marketing, my seminars, my mentoring program, and my video tutorials in my *Mastery Workshop on DVD* series.

Information on all these opportunities is available on my website, Beautiful Landscape (www.beautiful-landscape.com). I also offer a free newsletter. When you subscribe to my newsletter you receive over 40 free essays that are not in this book. The subscription link is on the home page of my website.

You may find that attending one of our field workshops, or one of our seminars, is the next step in your photographic journey. Our workshops and seminars are designed around the concepts outlined in this book and in my three other books: *Mastering Landscape Photography; Mastering Photographic Composition, Creativity and Personal Style;* and *Marketing Fine Art Photography.* If you enjoy reading my books you will enjoy attending our workshops. I say *our* because the workshops are taught by myself and by my wife, Natalie. Natalie is an art teacher who offers her own perspective and approach to our alumni.

Our workshops go further than this book by providing you with my latest research and with personal feedback on your marketing and your photography. There comes a time when it is necessary to find out what you need to do to reach

the next step. To this end, each of our workshops and seminars includes a detailed evaluation of your work. If this is what you are looking for, I recommend you visit my website and contact us by email or phone: alain@beautiful-landscape.com, 928-252-2466 and 800-949-7983.

Starting my photography business has changed my life. I certainly hope that starting your own photography business, or making your existing business better, will change your life as well. Giving you the knowledge to build a successful and profitable photography career is the goal of this book and of my other book on marketing.

Just keep in mind that the best time to get started is now. The best time is not tomorrow, not a month or a year from now, but right now. It is not too late, and there will never be a better time.

Alain Briot

Alain's Approach to His Photography

My photographic work is primarily about form and color. For some photographs, I am first attracted by the form of the subject, while for other photographs I am first attracted by the color of the subject. What attracts me first depends on the subject and how it inspires me.

My goal is always to create images in which both form and color are the primary source of interest. I am able to achieve this 85 percent of the time. However, with some images I cannot make both form and color work together to follow my vision. When this happens, I often convert the color image to black-and-white. In these instances, the images become purely about form since color is absent.

When the composition of an image does not work, I attempt to make the image purely about color. This is one of the most difficult exercises. So far, there have been very few instances when I was able to create a successful image whose interest is generated by color alone.

The original image captured by the camera cannot express my vision of form and color. To express what I see and feel in the field, I have to modify the original capture in order to reflect my artistic vision. To this end, rather than present the RAW images captured by the camera, I alter the colors, contrast, form, format, dynamic range, and many other aspects of each image. Depending on the specific photograph, I may also add or remove items, or I may create a composite made up of several photographs.

As a result, the images you see in this book should not be construed as representing something that truly exists. The purpose of my images is not to document the world we all have access to. Instead, my images are intended to be seen as a representation of my creativity, my artistic intent, my vision, and my desire to create a unique world.

Sandstone Waves and Clouds © Alain Briot ▶

TECHNICAL INFORMATION

Technical Information for the Featured Images

Front cover
Artist: Alain Briot
Title: *White Sands Moonrise*
Camera: Canon EOS-1Ds Mark II
Lens: Canon 70–200mm zoom set at 200mm with 1.4x extender
Exposure setting: ISO 50, 1 sec. at f/32
This photograph was taken at sunset as the moon was rising. The smoke from a forest fire east of where I was located filtered the sunlight and turned the sky various shades of red, yellow, and pink. I used a telephoto lens to magnify the moon and the yucca plant.

Page vi
Artist: Alain Briot
Title: *Mono Lake Sunset Vertical Collage*
Camera: Hasselblad 503CW with Phase One P45 digital back
Lens: Hasselblad Distagon 60mm f/3.5 CF T*
Exposure setting: ISO 100, 1 sec. at f/22
This image is a collage of two vertical wide-angle captures. When I photographed this scene I was captivated by the clouds and by the rocks in the foreground. Using a vertical panoramic format allowed me to include both in the same image. The color palette of this image is almost monochromatic, featuring pinks, mauves, and blues. I emphasized these colors to create a feeling of peaceful quietness.

Page x
Artist: Alain Briot
Title: *Antelope Sky Dance*
Artist: Alain Briot
Camera: Canon EOS 60D
Lens: Sigma 12mm
Exposure setting: ISO 100, ½ sec. at f/16
The camera was placed close to the ground, on a tripod, pointed straight up toward the sky. I rotated the LCD screen and used live view to compose the photograph. I could not have created this image without these features because the camera was too close to the ground to look through the viewfinder. This image is not an HDR photograph or a composite of two different exposers. The entire dynamic range of this scene was captured on a single photograph. I used Adjustment Layers in Photoshop, following a custom workflow I designed after years of practice. This process allows me to achieve details in both highlight and shadow areas within a single capture.

Page 1
Artist: Alain Briot
Title: *White Sands Sunrise*
Camera: Hasselblad SWC/M CF with Phase One P45 digital back
Lens: Biogon 38mm
Exposure setting: ISO 50, 2 sec. at f/22

This is a composite of two exposures. I wanted to capture a wide field of view to express the vastness of this scene, but my widest lens only captured half of what I wanted to show. So I took two photographs and stitched them in Photoshop using Photomerge to create the image I had visualized in the field. I also modified the colors captured by the camera to create the color palette I wanted to use. This palette consists of soft pinks, yellows, and mauves arranged in a contiguous color harmony.

Pages 14–15
Artist: Alain Briot
Title: *Mission and Ladder*
Camera: Canon EOS-1Ds Mark II
Lens: Canon 45mm tilt-shift
Exposure setting: ISO 100, $\frac{1}{125}$ sec. at f/16
The original capture was converted to black-and-white in Photoshop using Adjustment Layers. I rendered the sky pure black to create a dramatic effect and to emphasize the contrast between the sky, the white crosses, and the white mission wall. I was inspired by Ansel Adams's work when I created this photograph because during our photographic expedition to New Mexico, we visited the location where Ansel Adams created his famous photograph, *Moonrise, Hernandez, New Mexico*.

Page 16
Artist: Alain Briot
Title: *Alabama Hills Arch at Sunset #1*
Camera: Canon EOS 60D
Lens: Sigma 12mm
Exposure setting: ISO 100, ¼ sec. at f/22
The star effect was created by closing the lens down to its smallest opening and positioning the camera so that the sun was half hidden behind the arch. This effect makes the sun a focal point and adds drama to the image. The composition follows a diagonal line from top left to bottom right. The diagonal line is accentuated by the position of the sun and the light shining on the rocks and bushes in the foreground.

Page 22
Artist: Alain Briot
Title: *Surrealist Cloudscape Hoodoo*
Camera used: Hasselblad SWC/M CF with Phase One P45 digital back
Lens: Biogon 38mm f/4.5 CF T*
Exposure setting: ⅛ sec. at f/22
This original photograph is horizontal. I stretched the sky in Photoshop to create a vertical image in order to achieve my vision of a set of clouds appearing to dance over the stone hoodoo. Doing so increased the importance of the clouds and made them the focus of the image. It also emphasized the relationship between the sky, the clouds, and the hoodoo.

Page 30
Artist: Alain Briot
Title: *Fall Colors Along Canyon Wall, Zion National Park*
Camera: Hasselblad 503CW with Phase One P45 digital back
Lens: Zeiss Sonnar 250mm f/5.6 CF T*
Exposure setting: ISO 50, 1 sec. at f/32

I did not have a lens that would have allowed me to create this exact composition. The lenses I had with me provided images that were either too wide or too tight. So I took four exposures and stitched them together in Photoshop using Photomerge to create the exact composition I had in mind.

Page 35
Artist: Alain Briot
Title: *Sunrise Reflections, Bosque Del Apache, New Mexico*
Camera: Hasselblad 503CW with Phase One P45 digital back
Lens: Zeiss Sonnar 150mm f/4 CF T*
Exposure setting: ISO 50, 4 sec. at f/8
This was the first photograph I created that morning. When I saw this image on the LCD screen of my digital back, I had the feeling it was the one I would keep from that morning's shoot. I was correct. I did not use any of the other photographs I took that morning!

Pages 42–43
Artist: Alain Briot
Title: *Blue Mesa Cottonwoods*
Camera: Canon EOS 60D
Lens: Canon 90mm
Exposure setting: ISO 100, $\frac{1}{125}$ sec. at f/8
I had driven past this location several times but never stopped to photograph this scene. Either the light was wrong, or the trees had no leaves, or I could not find a composition that I liked. On one particular day everything was right. The cottonwoods were at the peak of fall colors, the shaded mesa appeared light blue, and I found the composition I was looking for. Back in my studio I enhanced the color and the contrast in Photoshop to create a blue-yellow complementary color harmony.

Page 48
Artist: Alain Briot
Title: *Alabama Hills, Eastern Sierra Nevada*
Camera: Hasselblad SWC/M CF with Phase One P45 digital back
Lens: Biogon 38mm f/4.5 CF T*
Exposure setting: ISO 50, ½ sec. at f/22
I wanted to express the feeling of space that seeing this scene gave me. However, I did not have a lens wide enough to capture the composition I had in mind. So I took two horizontal photographs and stitched them together in Photoshop using Photomerge to create the composition I visualized in the field. In addition, I stretched the sky and warped the arch in order to create the shapes I wanted to show in this image. The final image reflects my vision of the original scene.

Page 53
Artist: Alain Briot
Title: *The Watchman at Sunset, Zion National Park*
Camera: Hasselblad SWC/M CF with Phase One P45 digital back
Lens: Biogon 38mm f/4.5 CF T*
Exposure setting: ISO 50, ¼ sec. at f/22
This is a composite of three horizontal photographs. I also stretched the mountain and warped the foreground to reflect my vision of the original scene.

Pages 56–57
Artist: Alain Briot
Title: *Impressionist Joshua Tree Sunrise*
Camera: Hasselblad SWC/M CF with Phase One P45 digital back
Lens: Biogon 38mm f/4.5 CF T*
Exposure setting: ISO 50, 3 sec. at f/22
This image is not an HDR photograph or a merge of two different exposures. The entire dynamic range of this scene was captured on a single exposure. I used Adjustment Layers in Photoshop, following a custom workflow I designed after years of practice, which allows me to achieve details in both highlight and shadow areas within a single capture.

Page 58
Artist: Alain Briot
Title: *Aspens in Snowstorm, Northern New Mexico*
Camera: Canon EOS-1Ds Mark II
Lens: Canon 70–200mm zoom set at 180mm
Exposure setting: ISO 100, ½₀₀ sec. at f/8
This photograph was taken during a February snowstorm in the mountains of Northern New Mexico. The snow fell so hard on that day that we almost got stuck on the paved road even though we were in four-wheel drive vehicle. Being able to capture this photograph made up for the inconvenience and inclement weather. As David Muench often says, "Bad weather makes for good photographs."

Page 61
Artist: Maggie Leef
Title: *Aspens in White*
Camera used: Panasonic DMC-FZ28
Lens used: Leica DC Vario-Elmarit at 26.7mm
Exposure setting: ISO 400, ¼₄₀ sec. at f/4.0
I was documenting the aftermath of the Wallow Fire in eastern Arizona with only my point-and-shoot camera in tow. Scattered among the many burnt trees I found stands of aspens with seeds. This design is part of a horizontal image that I cropped and enhanced in Photoshop using Levels, Curves, and Shadows/Highlights. I then added Layer Styles (Stroke, Inner Glow, and Drop Shadow). Lastly, I added a bark pattern overlay on the border.

Page 67
Artist: Bill Irwin
Title: *Clearing Storm, Lindis Pass*
Camera used: Hasselblad H4D-40
Lens: Hasselblad HC 50-II
Exposure setting: ISO 100, ½₅₀ sec. at f/7.1
There was rapidly changing, bright light through the valley as storm clouds were breaking up. Post-processing was quite minimal, mainly emphasizing the area of brighter light and adding some saturation/warmth. This location usually looks like a big, burnt, brown landscape, but in overcast weather the original capture didn't quite reflect that.

Page 77
Artist: Bob Fields
Title: *Commodore Mine at First Light*
Camera: Canon EOS 5D Mark II

Lens: Canon EF 70–200mm f/4L IS USM zoom set at 165mm
Exposure setting: Aperture Priority, ISO 100, ¹⁄₁₂₅ sec. at f/8.0.
Initially Processed in Lightroom 4.0. Later, in Lightroom 5.0, I did some slight cropping and artifact removal of a large black board that stuck out of the top of the wooden structure at the bottom of the image. I slightly lightened the green foliage on the right of the image. Other than that, I adjusted the White and Black points, applied some Sharpening, slightly adjusted Contrast and Exposure, and pushed the Vibrance and Clarity a bit. I used Photoshop CS6 to interpolate to 8x10 size and 300 ppi for publishing. The image was taken on July 21, 2010, at 9:00 a.m. In this very steep canyon, the first light doesn't begin to hit the walls until around 8:45 a.m.

Page 85
Artist: Christophe Cassegrain
Title: *Paria Soul*
Camera: Linhof Master Technika 4x5
Lens: Schneider APO-SYMMAR-L 120/5.6
Exposure settings: 1 sec. at f/45
Film used: Fujichrome Velvia RVP 50

Page 93
Artist: Carl Johnson
Title: *Wolf Tracks on Ice*
Camera: Nikon D700
Lens: Nikkor 24–70mm f/2.8 AFS
Exposure setting: ¹⁄₈₀ at f/22
I performed some basic processing in Lightroom to increase contrast and saturation.

Page 99
Artist: Ruth C. Taylor
Title: *Autumn Stroll Along the Canal*
Camera used: Nikon D70
Lens used: Nikkor 18–200mm VR set at 50mm
Exposure Time: ¹⁄₃ sec. at f/20
Processed with Capture NX2. The image was taken on November 4, 2007, at approximately 2:20 p.m.

Page 105
Artist: Carol Boltz Mellema
Title: *Peek-A-Boo!*
Camera: Canon EOS 5D
Lens: Canon 70–200mm f/2.8 IS USM
Exposure Setting: ¹⁄₂₀₀ sec. at f/4
Minimal post-processing done in Photoshop.

Page 113
Artist: J.R. Lancaster
Title: *Monarch Cave Ceiling*
Camera: Deardorff 8x10 (circa 1952)
Lens: 240mm Gold Dot Dagor
Exposure setting: ½ sec. at f/45

The image required extreme titling of the camera axis due to the subject being directly overhead on a cave ceiling. An 81B warming filter was also used, if memory serves me right. I used that filter for most low light conditions.

Pages 122–123
Artist: Alain Briot
Title: *Moonset at Sunrise, Zabriskie Point, Death Valley, California*
Camera: Hasselblad SWC/M CF with Phase One P45 digital back
Lens: Biogon 38mm f/4.5 CF T*
Exposure setting: ISO 50, 1 sec. at f/22
This is a stitched panorama of five vertical photographs. The sunrise that morning was incredible and I could not decide where to point my lens. So I photographed the entire scene, from left to right, covering over 180 degrees of view, thinking that I would make the final crop later in my studio after stitching the images together. However, the entire scene was captivating and I ended up not cropping anything out. I did a little bit of warping and stretching in the sky and the land to make up for blank areas in the original composite, and to make the cloud and rock formations conform to my artistic vision. The version featured here shows only part of the complete panorama. The image was cropped to make it fit the format of this book. You can see the entire photograph on my website, beautiful-landscape.com, in the Portfolio Galleries, Best of 2013 page.

Page 124
Artist: Alain Briot
Title: *Sand Waterfall*
Camera: Hasselblad 503CW with Phase One P45 digital back
Lens: Hasselblad Distagon 60mm f/3.5 CF T*
Exposure setting: ISO 100, 4" at f22
In this image, I wanted to emphasize the movement of the sand falling from the sandstone ledge to the ground. To this end, I cropped the original capture slightly to create a tall, vertical image. However, this was not enough to exaggerate the feeling of motion, so I also stretched the image vertically. This increased the length of the sand waterfall, made the image taller, and allowed me to achieve the effect I was looking for.

Page 128
Artist: Alain Briot
Title: *Monument Valley Avant Garde*
Camera: Hasselblad 503CW with Phase One P45 digital back
Lens: Hasselblad Zeiss Distagon 60mm f/3.5 CF T*
Exposure setting: ISO 50, ½ sec. at f/22
This is a composite of three photographs. I stretched the sky and warped the dead tree and the sand patterns in the foreground to reflect my artistic vision of the original scene. The term avant garde in the title is a reference to art movements that use a cutting edge and non-conformist artistic approach. I feel that I achieve this in my work based on the amount of criticism I receive from people who believe that photographs should not be altered except to adjust contrast and color balance. These people call expressing your vision "manipulation," a term I find more derogatory than descriptive. When asked if I manipulate my work my answer is always a simple "yes."

On the Prices page on my website I offer a guarantee that expressly states that if someone purchases one of my photographs and it turns out that the photograph was not manipulated, they can return it for a refund. I do not take any chances by offering

this warranty because all my images are modified, or manipulated if you will, to reflect my personal vision of the original scene.

Page 132
Artist: Alain Briot
Title: *Sandstone Waves Black and White #1*
Camera: Hasselblad SWC/M CF with Phase One P45 digital back
Lens: Biogon 38mm f/4.5 CF T*
Exposure setting: ISO 100, ¼ sec. at f/22
The original photograph is a horizontal capture. To create a vertical composition, I started by increasing the canvas size in Photoshop to get a vertical, 4x5 ratio image. I then stretched the foreground rock formation until I had a vertical image. Stretching the image increased the dynamic feeling of the sandstone patterns. I also warped the rock formation at the top of the image to increase its height, give it more character, and make it a dominant visual presence.

Page 138
Artist: Alain Briot
Title: *Mobius Arch and Moon*
Camera used: Canon EOS 60D
Lens: Sigma 12mm
Exposure setting: ISO 100, 3 sec. at f/8
This photograph was taken during my 2012 Death Valley and Alabama Hills Workshop. Jacob Buchowski, one of my students, did some night photography at this location. Before sunrise Jacob pointed out to me the potential offered by the moon rising over the arch. This image was inspired by Jacob's suggestion.

Page 143
Artist: Alain Briot
Title: *White Sands Sand Storm*
Camera: Canon EOS 60D
Lens: Sigma 12mm
Exposure setting: ISO 100, ¹⁄₁₂₅ sec. at f/8
This photograph was taken hand-held during a sand storm. The wind was blowing so hard I could barely stand on my feet and was only able to photograph for an hour before I got tired of the sand blowing on my face. The image was originally captured in horizontal format; however, later, while back in my studio, I decided to stretch the bottom half of the image in Photoshop until I had a vertical, 4x5-ratio image. Doing so allowed me to recreate the feeling of seeing the sand blowing in the wind in front of me while I walked on the dunes. It also created a powerful visual effect: each time I look at this image I feel that the sand patterns are moving in front of me.

Page 146
Artist: Alain Briot
Title: *Sunset Near Lake Powell, Arizona*
Camera: Canon EOS 60D
Lens: Sigma 12mm
Exposure setting: ISO 100, ¹⁄₁₅ sec. at f/22
This image was taken while the last rays of sunset were striking the sandstone forma-tion in the foreground. This formation is naturally white but it appears pinkish-orange at sunset. I waited until the color was just right to take the photograph. This image is

a perfect example of exaggeration. Notice how the foreground covers over half of the photograph. I used an extreme wide-angle lens, and by tilting the lens down so that it pointed toward the ground instead of toward the horizon, the size of the rock formation in the foreground is exaggerated.

Page 151
Artist: Alain Briot
Title: *Sunrise on the Playa, Death Valley National Park*
Camera: Hasselblad 503CW with Phase One P45 digital back
Lens: Hasselblad Zeiss Distagon 60mm f/3.5 CF T*
Exposure setting: ISO 50, 1 sec. at f/22
This photograph was taken about 30 minutes after I took the photograph featured on page 136. By then the sun was higher up in the sky and the light had increased in intensity. The super-saturated colors of pre-dawn light were gone, now replaced by the pastel colors typical of sunrise. I composed the image to capitalize on the cloud forma-tion reflected in one of the pools of water that I found while walking on the Death Valley Playa. I am captivated by reflections and am always on the lookout for the photographic possibilities they offer.

Pages 154–155
Artist: Alain Briot
Title: *Arches at Sunrise*
Camera: Hasselblad 503CW with Phase One P45 digital back
Lens: Hasselblad Zeiss Distagon 60mm f/3.5 CF T*
Exposure setting: ISO 50, ¼ sec. at f/22
This image is a composite of two exposures. I could not make it work as a color image, so I converted to black-and-white when processing the RAW image. Later on, I realized that the image would work in monochrome, so I added the sepia color effect using Adjustment Layers in Photoshop. I did some significant shadow and highlight recovery in order to minimize the extreme contrast present in the original scene. I also dodged and burned both shadows and highlights to create a dramatic relationship between the sky, the clouds, and the arch.

Page 161
Artist: Alain Briot
Title: *Eye of the Wind Arch and Sky*
Camera: Canon EOS 60D
Lens: Sigma 12mm
Exposure setting: ISO 100, ⅟₃₀ sec. at f/22
To create this photograph I placed my camera close to the ground, on a tripod, and pointed it straight up toward the sky. Because there was not enough room under the camera for me to look through the viewfinder, I rotated the LCD screen and used live view to compose the image. I could not have created this image without these features because the camera was too close to the ground to look through the viewfinder. This image is not an HDR photograph or a merge of two exposures. The entire dynamic range of this scene was captured in a single exposure. I use Adjustment Layers in Photoshop, following a custom workflow that I designed after years of practice, which allows me to achieve details in both highlight and shadow areas within a single capture.

Page 168–169
Artist: Alain Briot
Title: *Sandstone Waves and Clouds*
Camera: Hasselblad SWCM-CF with Phase One P45 digital back
Lens: Biogon 38mm f/4.5 CF T*
Exposure setting: ISO 100, ½ sec. at f/22
I create black-and-white images when the colors in the photograph are not to my liking. Such was the case in this instance. Color simply did not work, but the forms in this image were so captivating that I had to make something of it. Converting it to black-and-white did the trick, so to speak. I increased the local contrast in the clouds to emphasize the swirling motion pattern in the sky. Doing so created a visual relationship between the tumultuous sky and the flowing lines of the sandstone below.

Page 180
Artist: Natalie Briot
Title: *Portrait of Alain Briot at Work*
Camera: Canon PowerShot G9
Lens: Canon PowerShot G9 built-in zoom lens
Exposure setting: ISO 200, $\frac{1}{125}$ sec. at f/5.6
My wife Natalie took this photograph while I photographed a sunset scene in Joshua Tree National Park. I cropped the original capture to square format to emphasize the composition and to fit the format of this book. This image is also used on my website as well as on Facebook, Google+, LinkedIn, and other social media sites.

Back cover
Artist: Alain Briot
Title: *Mono Lake Sunset*
Camera: Hasselblad 503CW with Phase One P45 digital back
Lens used: Sonnar 250mm f/5.6 CF T*
Exposure setting: ISO 50, 1 sec. at f/32
Personal and artistic notes: I wanted the format of the image to follow the shape of the rock formation, so I cropped to original image to this panoramic format. I also wanted to focus on the relationship of the colors in the rocks, the clouds, and the water, so I used a complementary color palette that consists of oranges with a touch of blue for the mountain in the distance.

About Alain Briot

There is nothing like a dream to create the future.
VICTOR HUGO

O riginally from Paris, France, I have lived in the United States since 1986. I live in Arizona and my favorite photographic locations include Navajoland, where I lived for seven years. I also enjoy photographing the rugged canyonland wilderness of southern Utah and northern Arizona. These unique natural locations were determining factors in my decision to live in the Southwest.

I currently work primarily with a Phase One digital back on a Hasselblad V. Hasselblad discontinued the V Series in April 2013, but I continue to use mine because I like the edge contrast and color rendering of Zeiss lenses and no other medium-format camera accepts Zeiss lenses as of September 2013. I also use a Canon EOS 1D camera, also with Zeiss lenses. I choose which camera to use based on my vision for each specific photograph.

My goal is to create photographs that express my personal vision. My equipment, be it cameras, software, printers, etc., is chosen for its ability to make this possible. My vision of the landscape is of a place of beauty, a place where we can experience a direct contact with nature, a place where we can find respite from the pressures and stresses of the 21st century, and a place where I can find inspiration and freedom of expression.

I started studying photography in 1980 in Paris. Prior to that I studied painting and drawing at the Academie des Beaux Arts, also in Paris. In the United States, I received my bachelor's and master's degrees from Northern Arizona University in Flagstaff, Arizona, and I worked on my Ph.D. at Michigan Technological University in Houghton, Michigan. I made the decision to become a full-time photographer, artist, teacher, and writer after completing my Ph.D. studies.

Today, I consider myself both a professional practitioner and a student of photography. I write extensively about photography, both from a technical and from a creative perspective. My writings are inspired by my photographic work, my teaching, reading, research, and study of photography. Besides this book, my essays are available on my website (www.beautiful-landscape.com), on websites such as Luminous Landscape (www.luminous-landscape.com) and many others, in print publications, and in my three previous books:

Mastering Landscape Photography; Mastering Photographic Composition, Creativity, and Personal Style; and Marketing Fine Art Photography.

My photographs are created to reflect my artistic vision. To this end, rather than present the raw images captured by the camera, I alter the colors, contrast, forms, contents, format, dynamic range, and other aspects of each image. Depending on the image, items may be removed or added or several photographs may be collaged together. As a result, my photographs cannot be construed as something that truly exists. They are intended to be seen as a representation of my creativity, artistic intent, and desire to create a unique world rather than as documentary evidence of the world we all have access to.

I create fine art prints, teach workshops and seminars, create tutorials on DVDs, and mentor students in my one-on-one consulting program. All these resources are available on my website, Beautiful Landscape (www.beautiful-landscape.com). My teaching covers every aspect of photography from fieldwork to studio work, matting, framing, marketing, and more.

I always welcome your comments and questions. Don't hesitate to email me at alain@beautiful-landscape.com. I answer every email personally and I look forward to hearing from you.

Alain Briot,
Vistancia, Arizona
January 2014